ON THE COVER: In 1907, Hillsboro city leaders journeyed to the headwaters of Sain Creek to inspect the city's proposed new water supply. Pictured from left to right are (kneeling) Wesley W. Boscow and Bob Hartrampf; (standing) Emil Kuratli, Harry Bagley, Judge W. D. Smith, George Bagley, William Barrett, Art Shute, Bruce Wilkes, unidentified, Al Long, and Bill Pittenger (in the tree). (Courtesy of Washington County Museum.)

IMAGES of America
HILLSBORO

Kimberli Fitzgerald and Deborah Raber with the
Hillsboro Historic Landmarks Advisory Committee

Copyright © 2009 by Kimberli Fitzgerald and Deborah Raber with the Hillsboro Historic
Landmarks Advisory Committee
ISBN 978-0-7385-7182-9

Published by Arcadia Publishing
Charleston SC, Chicago IL, Portsmouth NH, San Francisco CA

Printed in the United States of America

Library of Congress Control Number: 2009926445

For all general information contact Arcadia Publishing at:
Telephone 843-853-2070
Fax 843-853-0044
E-mail sales@arcadiapublishing.com
For customer service and orders:
Toll-Free 1-888-313-2665

Visit us on the Internet at www.arcadiapublishing.com

*To our loved ones for their support and patience
as hours of research took us away from them,
and to future historic preservation efforts in Hillsboro.*

Contents

Acknowledgments		6
Introduction		7
1.	The Atfalati and East Tualatin Plains	9
2.	Columbia Becomes Hillsborough	21
3.	Fin de Siecle and the New Century	35
4.	Hillsboro Grows Up	57
5.	The Roaring Twenties, Depression, and War	85
6.	Changes in Our Second Century	107
Bibliography		127

ACKNOWLEDGMENTS

The authors thank the Washington County Museum staff for their patience and generosity in assisting our research and in reviewing the drafts of this book. Research in the museum's extensive collections was fascinating and made selection of a small number of photographs difficult. We encourage readers to discover this wonderful resource for themselves. Thanks also to private residents Mary Stafford, Dana McCullough, Harold Berger, Ruth Klein, and Earl Engebretson for sharing their photographs and their stories. Particular thanks are due to earlier compilers of histories and stories of Hillsboro, particularly those in the centennial issue of the *Hillsboro Argus*, the early history compiled by Dick Matthews, and *This Far Off Sunset Land* by Carolyn M. Buan. We acknowledge the valuable contributions and support of the Hillsboro Historic Landmarks Advisory Committee: Michael Quebbeman, Harold Berger, Neisha Cameron, Kay Demlow, Judy Goldmann, Bonnie Kooken, and Joan Krahmer. We are especially grateful to Debra Meaghers for her many hours of painstaking work in organizing, proofreading, editing, and finalizing multiple drafts. A final thanks to Arcadia Publishing editor Sarah Higginbotham, whose encouragement and exhortations both launched the book and guided its course through to completion.

Unless otherwise noted, all images are published with the permission of the Washington County Museum.

INTRODUCTION

The first inhabitants of the central Tualatin River basin were the Atfalati. These Native Americans burned the prairies to improve their harvesting and hunting, traveled to and from Willamette Falls to trade with other tribes for salmon and slaves, and gathered at places like Chatakuin (Five Oaks) to settle disputes, arrange transactions, and carry out their community affairs. These three functions—agriculture, commerce, and government—have defined the area now called Hillsboro since its earliest beginnings.

The first European and American residents arrived in the 1830s. They were retired Hudson's Bay employees from Canada; ex-mountain men like Joe Meek and Caleb Wilkins (sometimes with their Native American wives); and missionaries John and Desiree Griffin. Shortly thereafter, the second wave of immigrants came over the Oregon Trail, and the scattered farms became known as the East Tualatin Plains. The lives of the earliest white residents were stark and marked by isolation and hardship, but family friendships extending across generations began in these years. Two of the earliest settlers, David Hill and Isaiah Kelsey, sold or gave portions of their donation land claims for the creation of the first town plat in 1850. Had Hill lived longer, the new town might have been named Columbus as he wished, but his death prompted his neighbors to name the town in his honor instead. Although Hillsboro was the seat of the Tuality District, one of the Oregon Provisional Government's first four divisions, it remained for the next two decades a small agrarian community with just over 200 residents, primarily farming families reaping generous crops from the rich soil.

The arrival of the railroad in the early 1870s and the city's incorporation in 1876 were the catalysts of great changes, including the official renaming of the post office from Hillsborough to Hillsboro in April 1892. Farmers could now export their crops, and farm and forest businesses such as flour mills and lumber mills grew near the railroad station south of town. Concentrations of hardworking men patronized the town's four saloons, and their misbehavior earned the community the nickname of "Sin City," in contrast to "Piety Hill," its more sedate neighbor to the west (now Forest Grove). But family and cultural amenities—brass bands, literary societies, and temperance groups—also started during this boom time.

In 1890, the city passed an ordinance requiring that all commercial buildings be built of stone or brick to reduce the risk of catastrophic fires, which were common in early downtowns. This act, and the creation of districts for city power and water, changed the look and feel of the downtown from a frontier village with wooden storefronts to a substantial young city with entire blocks of two-story commercial buildings, planked streets, and wooden sidewalks. But despite its urban feel, downtown Hillsboro still hosted annual stallion shows, and the former County Fairgrounds just west of downtown became a horse-breeding farm and race track.

City leaders were proud of Hillsboro's new image at the beginning of the 20th century and sponsored an exhibit touting the community at the 1904 Lewis and Clark Centennial Exposition in Portland. The exhibit may or may not been the cause, but during the first decade of the

20th century, Hillsboro experienced its most significant growth to date, doubling in size in just 10 years to more than 2,000 residents. For the first time, the county seat was larger than its western neighbor Forest Grove. The bucolic farming village began a transformation into a working city with mills and factories processing grain, dairy products, and lumber. It also blossomed with the new culture of two live theaters and a Carnegie Library.

Interurban trains, the precursors of today's Metropolitan Area Express (MAX) lines, arrived in 1908 and 1912, opening up the possibility for city workers to enjoy a small-town lifestyle and commute to their jobs in the city. The interurbans also opened up new markets for local agriculture, from family berry farms to the fruit trees of the Oregon Nursery Company, to be sold nationally and worldwide. Family-oriented entertainment such as the Fourth of July Happy Days Festival (which endures to this day) also began during this time. Determined to put the former "Sin City" image behind them once and for all, Hillsboro's citizens voted the town dry in 1913, six years before the Volstead Act ushered in Prohibition across the rest of the country.

Growth in the early 1900s was the impetus for more urban amenities in the 1920s. The Shute and Bagley Parks were established, and the planking on downtown streets was replaced with paving. Hillsboro struggled with the rest of the nation through the Great Depression but found some relief through the Works Progress Administration (WPA) and the Civilian Conservation Corps (CCC) programs, which built a new post office and improved Shute Park. Hard economic times were somewhat improved during World War II when employment in Portland's shipyards fueled further housing growth in Hillsboro. The city received another economic stimulus during the war when the federal government funded extensive (but in the end, little-used) improvements to the fledgling Hillsboro airport as a national defense project.

When it emerged from the war in the 1950s, Hillsboro had a population of more than 5,000 and an economy firmly grounded in agriculture, as it had been for the last 100 years. The agricultural economy had shifted from subsistence crops to nursery stock and processing, but a larger transformation was coming. Just east of Hillsboro, a firm that manufactured oscilloscopes started business in 1951. Tektronix was the first seedling in today's "Silicon Forest," the concentration of high-tech firms clustered along Sunset Highway that would eventually broaden the agrarian economy and bring a new wave of immigrants, this time from around the world.

As noted by Dick Matthews in his 1985 *History of Hillsboro*:
> Hillsboro is sufficiently "of an age" where its essential character as a family town is well established. It is this historic character that will see the city through the changes yet to come. Hillsboro will no doubt remain a family town, with long standing traditions, as the nature of its newest families changes from farm to factory.

Hillsboro is now more than halfway into its second century as a community. Awareness of local history is spreading, and the benefits of preserving our past are more widely embraced for the sake of both community identity and sustainability. Our city stands ready to build its future and write more chapters of its history on the foundation of its rich past.

One

THE ATFALATI AND EAST TUALATIN PLAINS

At the time Europeans and Americans arrived in what is now Washington County, there were several bands of Atfalati, branches of the larger Kalapuya tribe who lived throughout the northern Willamette Valley. The Atfalati winter camps were located around Wapato Lake, east of Gaston, and scattered on the northern Tualatin Plains near present-day Forest Grove, Hillsboro, and Beaverton. One major summer camp and gathering place was Chatakuin, now called Five Oaks, located north of Sunset High and east of Helvetia Road. Five Oaks remained a gathering place and rendezvous for newer arrivals as well.

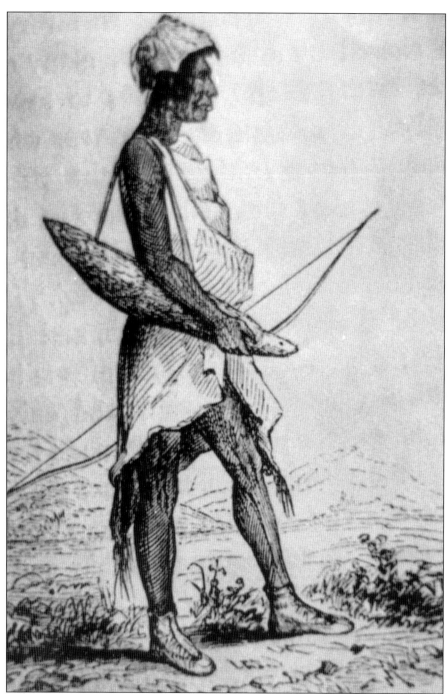

The arrival of the fur trappers and settlers marked the beginning of the end for the Atfalati. Initial contact with trappers in the late 1700s resulted in a smallpox epidemic. A second epidemic in the early 1830s caused the deaths of almost 90 percent of the tribe. A member of the 1838–1842 Wilkes Expedition drew this pencil sketch of a Kalapuyan hunter, which was originally published in Pickering's *The Races of Men and their Geographical Distribution* in 1863. The hunter appears to be wearing a hide tunic and carrying a quiver or pouch made from an animal skin.

When the first settlers arrived in the 1830s, the valley floor was an open prairie laced with forests along the creeks and the Tualatin River. The absence of brush was due to the Atfalati practice of prairie burning. This sketch was made by Joseph Drayton in 1841. (Courtesy of Oregon Historical Society, OHS Neg. 46191.)

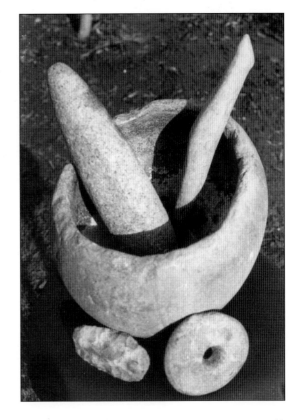

The Atfalati burned the plains to improve deer habitat for hunting. After burning, they harvested tarweed pods with hoops that looked like tennis rackets. Atfalati women and children would then beat the pods to release the seeds and grind them in a stone mortar mixed with hazelnuts or camas, an onion-like bulb.

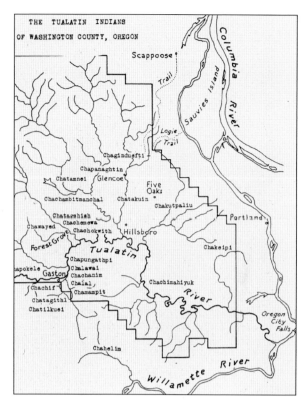

The Atfalati were not a prosperous tribe. Lacking access to salmon runs on the Willamette and Columbia Rivers, they gathered a sparse diet of nuts, roots, bulbs, and berries in a seasonal migration across the valley floor. The bands of the tribe regularly traveled eastward to Willamette Falls to trade for fish, furs, shells, or slaves. This map, drawn by Robert Benson, shows the anglicized spellings of several Atfalati bands and camp sites.

Relatively little is known about the beliefs of the Kalapuya. According to early accounts, they believed that they could acquire power from animals or other natural objects, which would give them magical strength and protection. They also believed in a divine being known as Ay-uthlme-I, which translates to "miraculous."

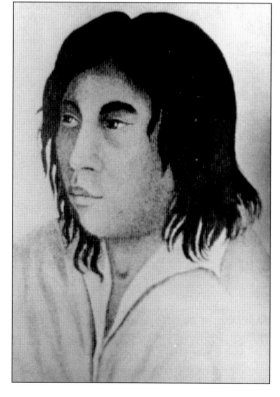

This pencil sketch, also by a member of the Wilkes Expedition, shows an older Kalapuyan man. According to early sources, the Kalapuya did not tattoo themselves, but many had flattened foreheads. Lewis and Clark had observed the practice of flattening infants' heads in their cradleboards among tribes along the Columbia River. (Image original to Pickering's *The Races of Men and their Geographical Distribution*, 1863.)

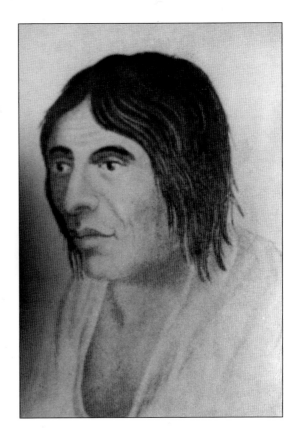

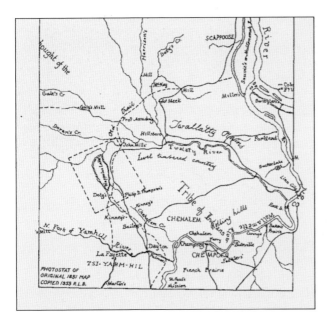

The Gibbs-Starling map, prepared in 1851, shows that American settlers originally designated an area of 12 square miles to the Atfalati, surrounding their traditional campsites near Gaston, denoted by the dotted square surrounding Wapato Lake. Joe Meek's name is shown on the map within the "Twallatty Plains" designation north of Hillsboro.

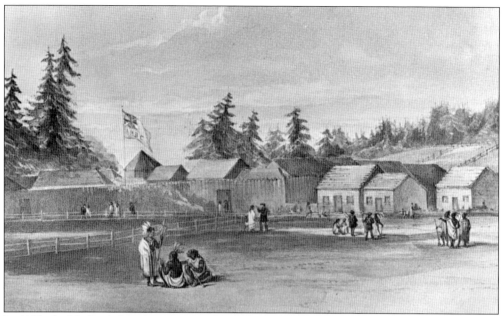

In 1824, the Hudson's Bay Company established a trading post at Fort Vancouver. Hudson's Bay workers and their families, originally from what is known as Manitoba, Canada, began settling the Tualatin Plains in the early 1840s and were known locally as the Red River settlers. They were joined by retired American fur trappers and mountain men such as Robert Newell, Caleb Wilkins, and Joe Meek. (Courtesy of Oregon Historical Society, OHS Neg. OrHi9257.)

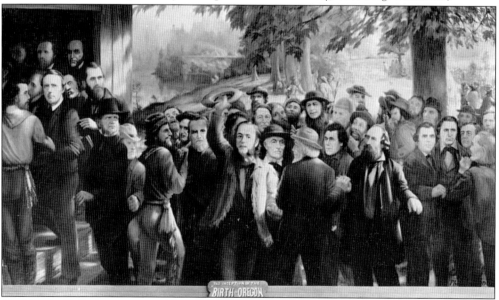

On May 2, 1843, American and British settlers met at Champoeg on the Willamette River to establish a provisional government in Oregon. Seen in this painting are Joe Meek (waving his hat) and Rev. John Griffin (behind Meek on the right). The provisional government was intended to safeguard American property interests until the British and American governments officially established a border and decided control of the Oregon territory. (Courtesy of Oregon Historical Society, OHS Neg. OrHi394.)

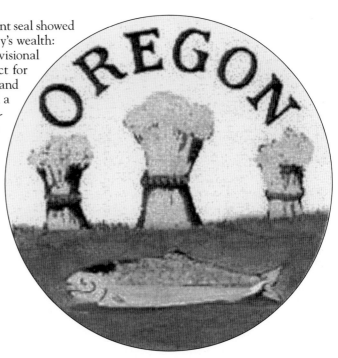

The 1843 provisional government seal showed the symbols of the new territory's wealth: fishing and agriculture. The provisional government remained in effect for three years while the American and British governments negotiated a boundary. In 1846, the Anglo-American Treaty set the U.S.–Canadian boundary at the 49th parallel, and in 1848, Congress made Oregon a territory.

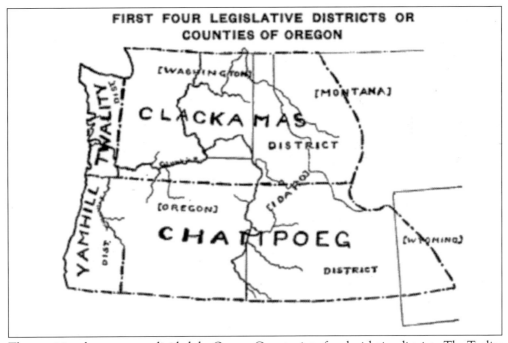

The provisional government divided the Oregon Country into four legislative districts. The Tuality District extended over an enormous area in both Oregon and Washington, as shown on this map. Portions of the district south of the Columbia River were divided into Washington, Multnomah, and Clatsop Counties in 1854. Since David Hill was a member of the Provisional Government Legislative Committee, the district seat was on his claim in the tiny settlement of Columbus.

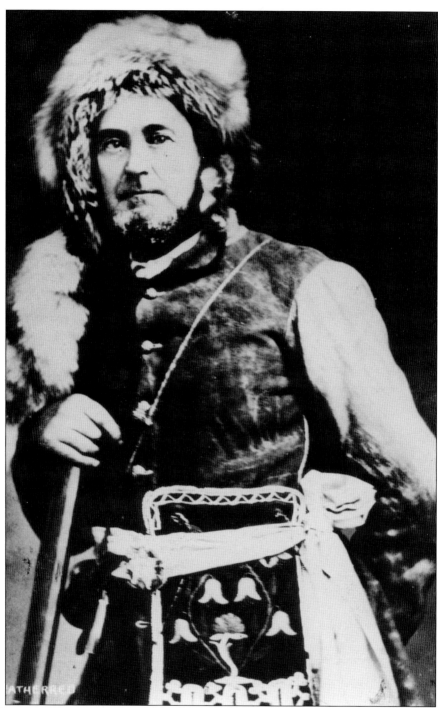

Joseph Lafayette Meek was born in 1810 in Washington County, Virginia. After trapping beaver in the Rocky Mountains, he moved west with his wife and children, reaching Columbus in December 1840. Meek built a cabin on his claim just west of present-day Jackson School Road, south of Sunset Highway. Other former trappers, including Robert Newell and Caleb Wilkins, settled nearby, and the vicinity became known as the Rocky Mountain Retreat.

Virginia Meek was Joe Meek's third wife, whom he married according to Native American custom in 1837. A member of the Kamaiah Band of the Nez Perce Indians of Northern Idaho, she was born in 1820. Joe called her Virginia after his home state. After they settled in Oregon, Joe and Virginia were married once again in 1841 by a local minister, possibly John Smith Griffin.

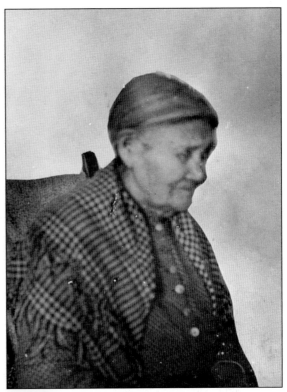

John Smith Griffin had originally planned to establish a mission east of the Cascade Mountains but had no support from his Congregationalist Church missionary board. Destitute, he and his wife, Desiree, received an opportune invitation from the mountain men to act as their minister in the summer of 1841. The Griffins relocated and established a mission and a prosperous farm northwest of present-day Evergreen and Cornell Roads.

Virginia and Joe Meek had 11 children; six died in childhood. Jennie Meek, pictured here, was born in 1852, married Charles Newhard in 1873, and lived in Idaho, where Newhard worked for the railroad. Her brother, Courtney Meek, helped survey the Nez Perce Indian Reservation in Idaho into 80-acre allotments that were given to the Nez Perce and their descendants. Virginia Meek, her children, and her grandchildren received 11 allotments near Fletcher, Idaho.

Cal Cornelius was one of the last Native Americans to live in East Tualatin Plains. He was given to James Imbrie by California tribes in the Sacramento Valley and lived with the Imbrie family for many years. After fighting in the Yakima War in 1856, he was removed from the Imbrie family and died in Yakima on the reservation there.

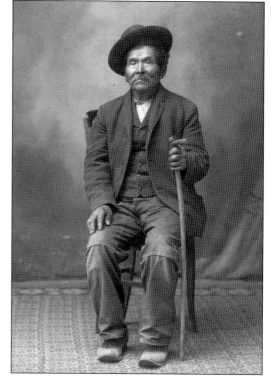

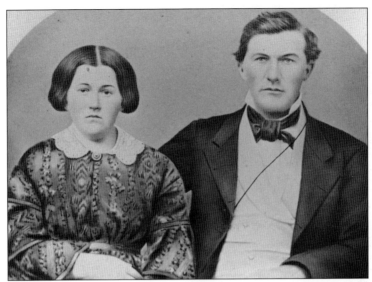

James and Mary Imbrie (pictured above) built a log cabin west of present-day Cornelius Pass Road, south of Sunset Highway, in March 1851. The cabin was replaced in 1866 by the large 12-room house (shown below), which still stands today. Frank Imbrie bought the family farm from his father, James, in 1929. Frank's son James noted that, over the years, the family raised cows, hops, grain, and clover to improve the soil. In 1951, the *Hillsboro Argus* commemorated the farm's centennial, and in the published interview, James Imbrie noted, "We always have something on the farm. It's good land. You'd think it'd wear out in 100 years." The farmstead was purchased by the McMenamin brothers in the 1990s and is now the popular Cornelius Pass Roadhouse and Brewery. The Imbrie granary, built around 1855, still stands as part of the brewery complex and is the second oldest building in Washington County.

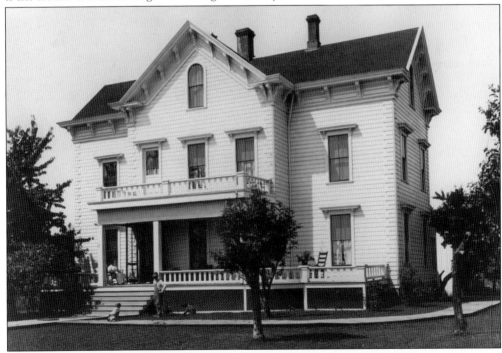

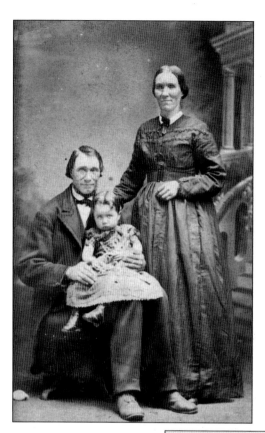

Isaiah and Winnie Kelsey came to Oregon in 1841 on the Oregon Trail and settled in the East Tualatin Plains along with two others, David Hill and Richard "Irish Dick" Williams. The Kelseys donated 12 acres from their donation land claim for the county seat, where the first courthouse was built in 1852.

The original 1850 plat of Hillsborough included portions of both David Hill's and Isaiah Kelsey's claims. Before his death in 1841, Hill sold 40 acres of his claim and a small log building to the county court for $200; he requested that the government plat a town and call it Columbia. After his death in 1850, it was decided to rename the settlement Hillsborough in his honor. (Courtesy of City of Hillsboro)

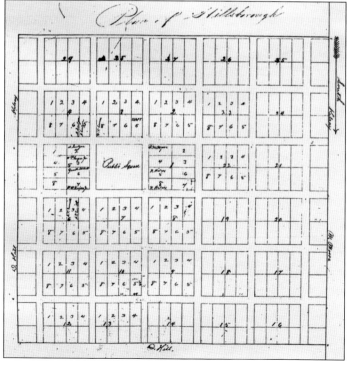

Two
Columbia Becomes Hillsborough

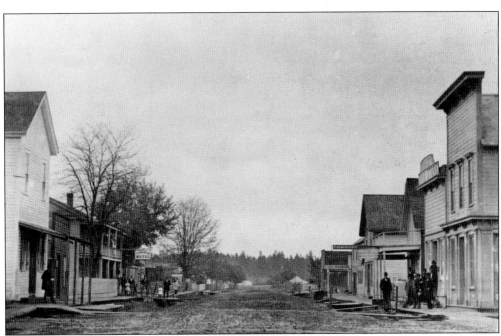

After 1850, Hillsborough grew slowly, and only the lots around the public square were purchased, generally by men who held government posts. By 1860, just 12 families lived in the new settlement, but there were two stores, one hotel, two blacksmiths, two wagon makers, a doctor, a lawyer, and a bookkeeper. This picture, taken in the 1870s, shows Main Street looking east from Second Avenue. By 1880, the population had risen to approximately 213 people, including 34 farming families.

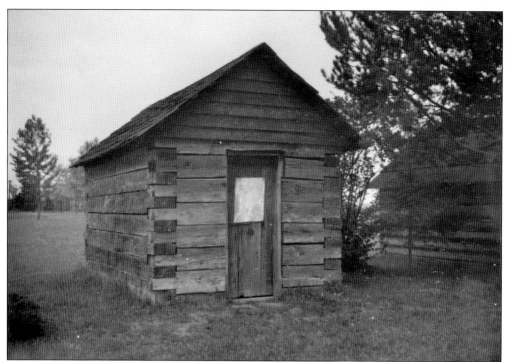

According to local legend, Ulysses S. Grant, a lieutenant in the U.S. Army in the 1850s, was held overnight in the Washington County jail, built in 1853. Stationed at Fort Vancouver as a quartermaster, Grant purchased $1,200 worth of supplies for the fort but was unable to make good on his draft for the supplies, so Sheriff Richard Wiley held him overnight. The building was used as a jail until 1870, when it was sold and used as an outbuilding.

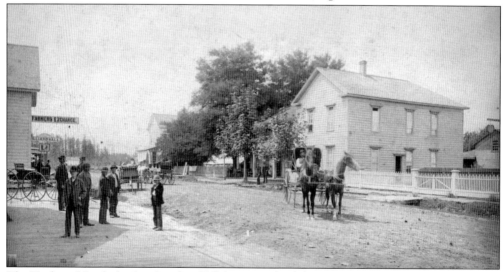

The Tualatin Hotel, the first hotel in Hillsboro, was built by Henry Wehrung in 1854. Wehrung also opened a furniture shop where he manufactured each piece of furniture by hand. An early leader in the Hillsboro community, he helped to build the first school in Hillsboro, as well as the first courthouse. In the 1880s, Wehrung built a splendid house, which still stands at the corner of SE Fifth Avenue and SE Washington Street.

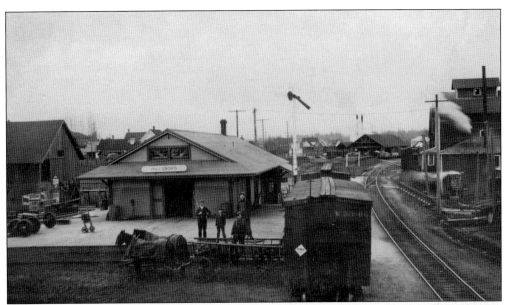

Ben Holladay's Willamette Valley Railroad reached Hillsboro in 1872. Rebuffed by local officials when he sought a free site in the center of the town, Holladay moved his plans for a railroad depot several blocks to the south. The Willamette Pacific line was built by the Oregon Central Railroad Company between 1869 and 1871. It was acquired by the Oregon and California Railroad in 1880 and, eventually, by the Southern Pacific in 1927.

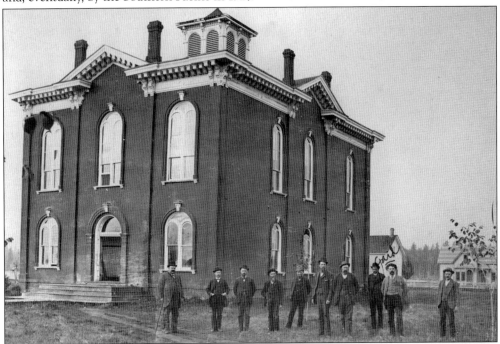

A two-story brick courthouse was constructed in 1873 to replace the earlier log courthouse donated to the city by David Hill. Hill's Tuality District courthouse had been a busy place. Before the creation of Multnomah and Columbia Counties in 1854, people filing deeds and other documents affecting properties in cities like Portland or St. Helens had to come to Hillsboro.

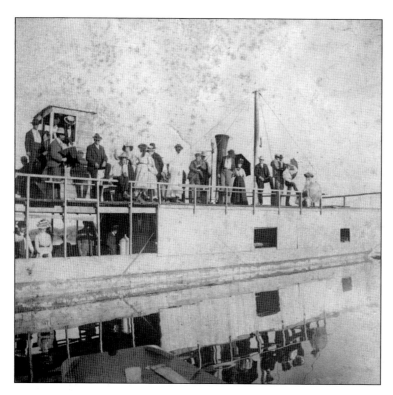

In the 1860s, the stern-wheeler *Onward*, with its three-man crew, made a weekly 60-mile, four-day journey to the Centerville landing near Forest Grove. An 1867 article in the *Oregonian* noted that "during high water in the [Tualatin] river, the bridges under which the steamer has to pass constitute something of a hindrance, but that is overcome, or rather undergone, by a hinge joint in the smokestack by means of which it can be let down on the deck."

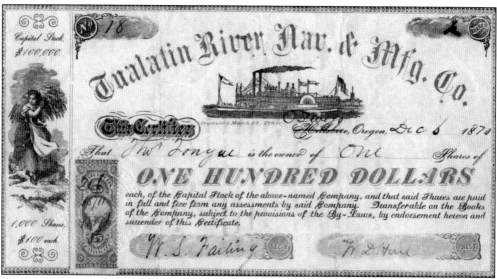

Recognizing the value of the rivers for transportation, the territorial legislature chartered the Tualatin River Transportation and Navigation Company to connect the Tualatin and Willamette Rivers in 1856 by building a canal and locks through Sucker Lake, now Lake Oswego. Although $16,000 was raised, the project was never completed.

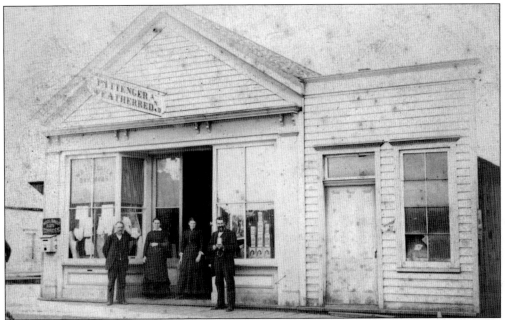

David Hill established the first post office sometime after 1843 and named it Columbia. It was renamed Hillsborough in 1850 but was discontinued on March 30, 1855. Later that year, it was reestablished, again as Hillsborough. By the 1870s, the Hillsborough post office was located in the Pittenger and Weatherred store at the southwest corner of Second Avenue and Main Street. On April 20, 1892, the post office name was officially changed to Hillsboro.

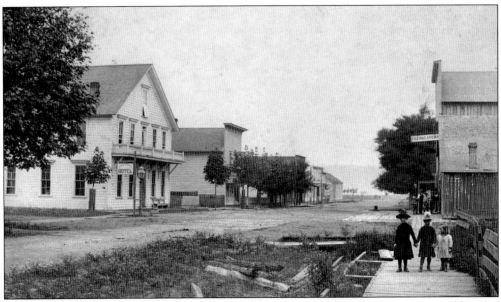

The Commercial Hotel was the second hotel established in Hillsboro. It was constructed by John Wood at the northwest corner of Southeast Washington Street and Southeast Second Avenue. It was operated by John and his wife, Mary Ramsey Wood. The hotel had a wooden balcony and was an attractive place to stay for visitors on business.

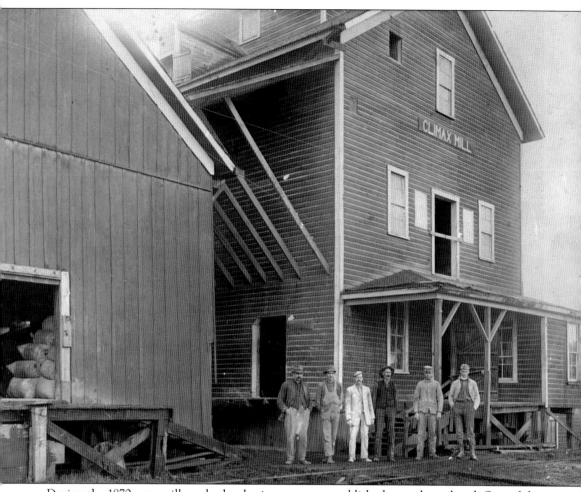

During the 1870s, sawmills and other businesses were established near the railroad. One of the largest, the Climax Mill, was located south of town along Second Avenue. Pictured here are (from left to right) a Mr. Heim, Mike Dooher, F. W. Kellington, Andy Miller, Charles Heim, and Charles Mitchell. The Climax Mill became the Imperial Mill, and eventually it became the largest grain facility in Oregon outside Portland. In 1947, the Imperial Feed and Grain Elevator caught fire. Trucks from eight departments were called up to battle the blaze, which engulfed three warehouses full of grain, the elevator, offices, the railroad depot next door, and a nearby residence. The worst fire in Hillsboro's history, it caused $300,000 of damage. The Imperial Feed fire was a devastating setback for local farmers. The mill was rebuilt in 1949.

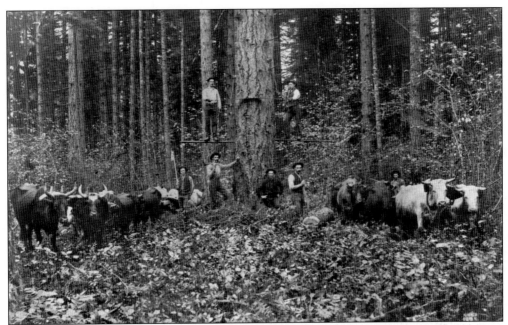

Trees were cut and cleared in the woods between Hillsboro and Forest Grove by loggers such as these from J. C. Hare's Hillsboro Lumber Company. The loggers stood on springboards cut into notches in the tree trunks and used long crosscut saws called "misery whips." After the huge trees were cut, oxen or horses hauled the logs out of the woods to the nearest river or railroad. The loggers remained in the woods and lived in logging camps.

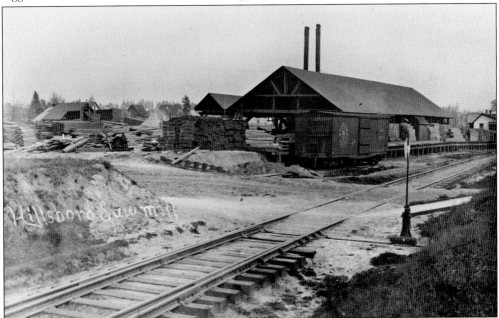

Cut logs were hauled to the Tualatin River and floated down to Hillsboro, often ridden by skilled log drivers who steered around the frequent snags. At the Hillsboro Sawmill, pictured here, the raw logs were cut and milled into boards or other products used primarily for construction. Cut boards were then shipped to Portland and beyond via the Oregon and California Railroad.

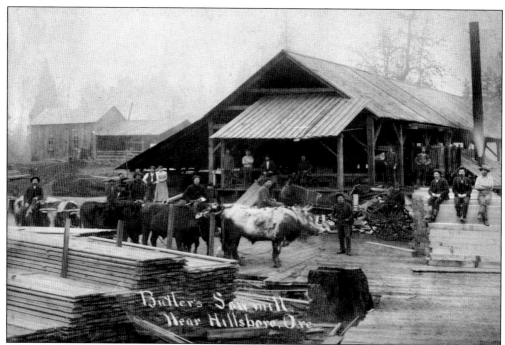

Logging was also done on a smaller scale in the Orenco area. Trees were harvested locally and cut and milled on site at the Butler Mill, located off Baseline Road near Rock Creek. The oxen pictured hauled the logs from the local forests to the mill to be cut into the milled boards seen stacked in the foreground.

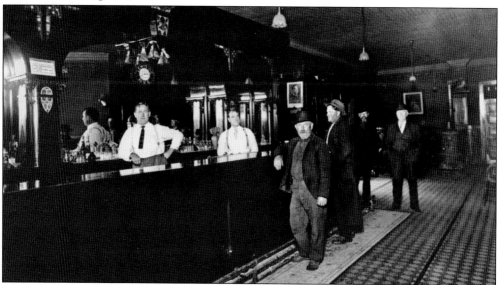

Thirsty loggers came into town to saloons such as Wiley's. Richard E. Wiley was said to have a pet goose, and when given spirits, the goose would stagger into the street at Second Avenue and Main Street. As resident May Lepschat recalled much later for the *Hillsboro Argus*, "Saloons were full of noise and laughter and women didn't go into such places." The bar from Wiley's was salvaged prior to the building's demolition; it was moved to the Coffee Grinder Restaurant in Forest Grove.

Rev. John S. Griffin purchased shares in the Portland and Valley Plank Road Company in 1851. The Canyon Road, a muddy track west from Portland along Tanner Creek, was the only route Hillsboro farmers could use to take produce east to Portland. The first plank of this road was laid on September 27, 1851, and was reportedly the first plank of any road on the Pacific Coast. Ten miles were completed before the money ran out.

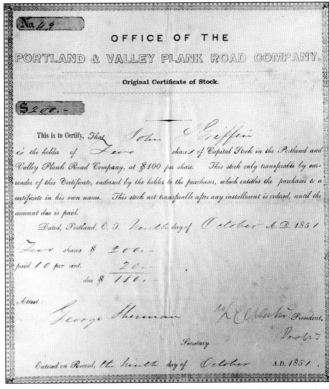

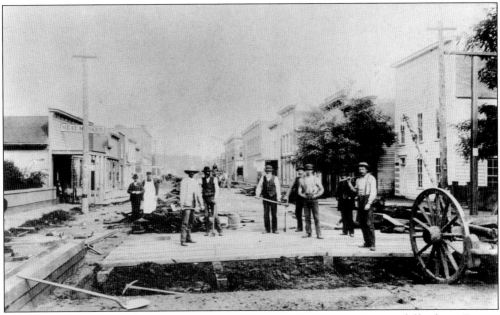

Dirt roads and streets became deep mud in the rainy season, causing many difficulties. Due to ongoing frustrations of Hillsboro and Tualatin Valley farmers, another road stock company was founded in 1872 to build the plank road to Portland. The Portland, Hillsboro, and Centerville Plank Company raised $80,000, but this attempt also failed, and the road was not fully completed until 1902. Pictured here, Hillsboro's dirt Main Street was planked in the early 1880s.

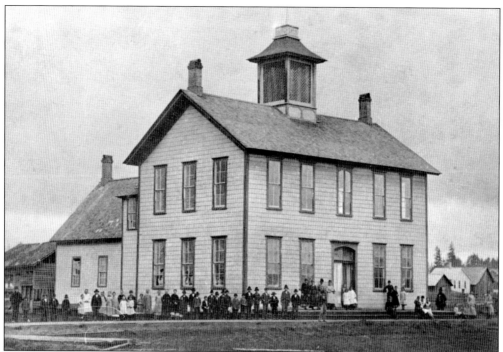

In 1853, two lots at Southeast Third Avenue and Baseline Street were purchased to build a log schoolhouse. This photograph, probably taken in the 1880s, shows the original log school in the rear, a second addition in the center, and a third, larger addition in the front. The original school complex burned down, and a new eight-room school was constructed in 1889 at Southeast Fifth Avenue and Oak Street, the present location of the David Hill School.

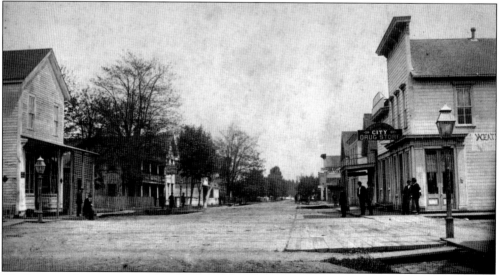

The business district was concentrated primarily within the four blocks around the intersection of Southeast Second Avenue and East Main Street, at the southeast corner of the public square. After the railroad came to town in 1872, the business district expanded southward down Second Avenue toward the train depot. This picture shows Main Street, looking east from Second Avenue, after the planking was completed.

The *Hillsboro Democrat* was established in 1869 and operated until 1873. Its offices were located on Southeast Second Avenue between Main and Washington Streets. The *Democrat* was an eight-column, four-page newspaper printed in Portland by Palmer and Rey. In 1873, the owners moved the paper to Forest Grove and renamed it the *Forest Grove Independent*.

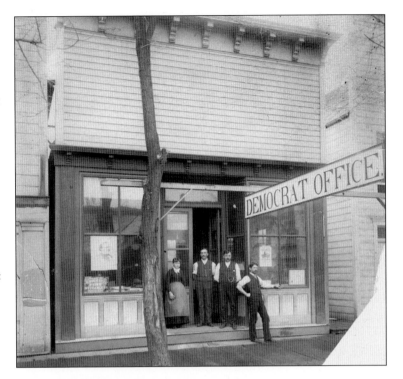

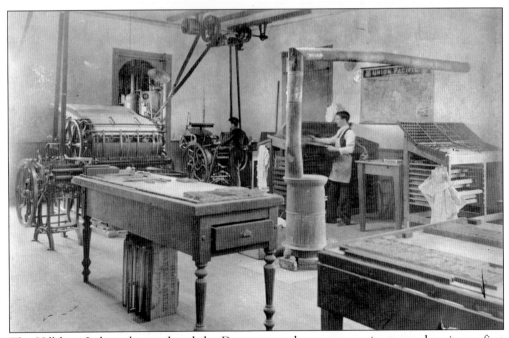

The *Hillsboro Independent* replaced the *Democrat* as the newspaper in town when it was first published in 1873 by H. B. Luce. Emma Carstens McKinney began as an apprentice typesetter for the *Independent* in 1888. The *Hillsboro Argus* was first published on March 2, 1898, from the offices of the former *Democrat* on Second Avenue. In 1904, McKinney bought a half interest in the *Argus*, which was merged with the *Independent* on February 1, 1932.

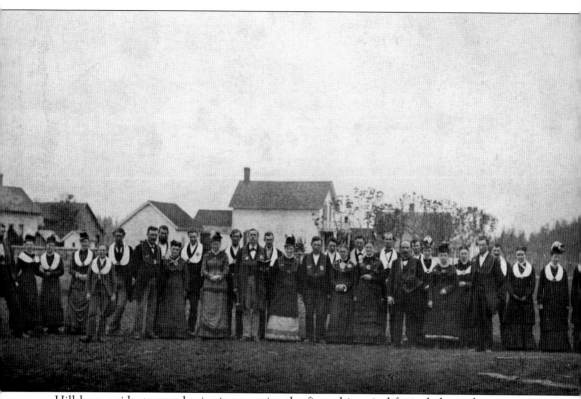

Hillsboro residents were beginning to enjoy the finer things in life, including a literary society and a brass band, established in 1875. The growing population also enjoyed community arts festivals and dances like the Volunteer Fireman's ball at the Opera House. Many of the prominent residents such as the Tozier, Morgan, Wehrung, and Weatherred families also joined community organizations such as the Independent Order of Good Templars Lodge No. 17, pictured here. The Templars were notable among the many temperance groups in that they allowed both men and women members.

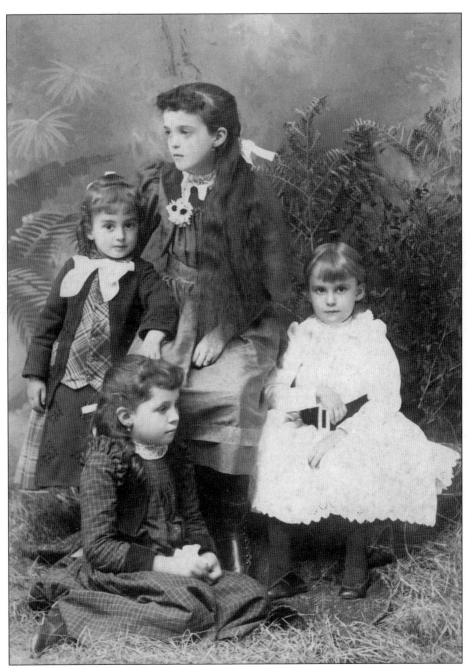

The Weatherred family was one of the most prominent families in Hillsboro, and the four Weatherred children are pictured here, from left to right, Robbie, Flosace "Flossie," Ava, and Tennessee "Tennie" (seated on the ground). The children posed for this picture in 1884 at a local photography studio. Tennessee Weatherred's mother, Frances, acquired a house from Elizabeth Milne near the intersection of Southeast First Avenue and Southeast Walnut Street where Tennessee lived for a number of years. This house, relocated and now facing Southeast Walnut Street, is the only residence in Hillsboro built in the Eastlake style, reflecting the Milne family's prosperity in the grain-milling business

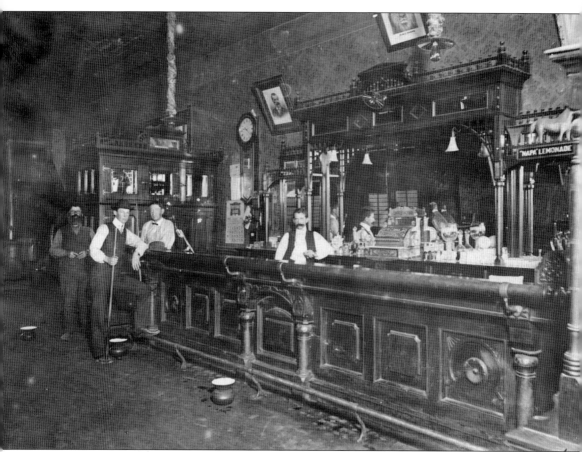

In contrast to the brass band, the opera house, the literary society, and the temperance group, Hillsboro had four saloons by the early 1880s and began to be known as "Sin City." Forest Grove to the west, home of Pacific University, was known as "Piety Hill." Ed Lyon's Thirst Emporium was typical of these ornately furnished establishments. Although local men enjoyed the saloons, public drunkenness and disorderly behavior were not tolerated, resulting in several local ordinances regulating saloon hours. The *Argus* reported that 20 young men, tired of a Mr. Tromley's drunkenness, broke him out of jail and tarred and feathered him on Main Street.

Three

FIN DE SIECLE AND THE NEW CENTURY

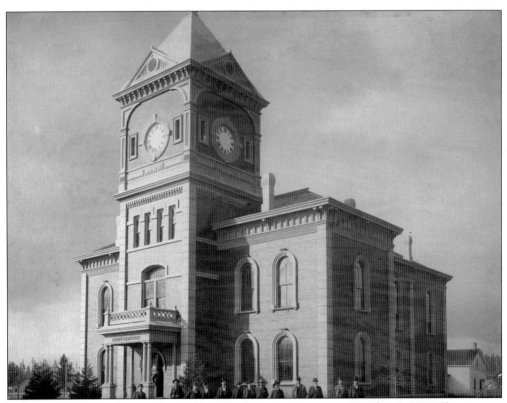

Hillsboro was granted a city charter from the State Legislature on October 5, 1876. The city was incorporated under the name Hillsborough with a board of trustees and a president. This new brick courthouse was finished in 1873 at a cost of $12,392.56, over budget by $392.52. The clock tower was added in 1891. John Porter, a pioneer nurseryman, planted the landmark sequoias in 1880 at the entrance to this new courthouse. The official name of the town's post office was changed to Hillsboro in April 1892.

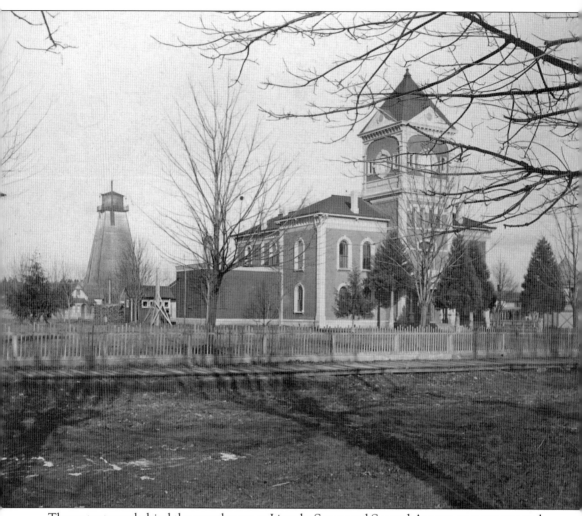

The water tower behind the courthouse, at Lincoln Street and Second Avenue, was constructed in 1892–1893. It greatly improved the city's ability to fight fires, a common hazard in a town where nearly all the buildings were of wood construction. At about the same time, an electric plant was also built. The novelty of the new electric streetlights necessitated a city ordinance making it illegal to break them, since some residents and visitors thought it great fun to break them by throwing rocks. This picture was probably taken sometime around 1900.

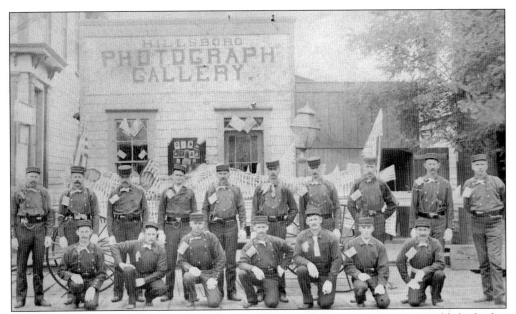

A volunteer fire department was established in 1880. By 1890, a city ordinance established a fire district encompassing the commercial center downtown. Within the boundaries of the district, new buildings were required to be built of brick or stone. A 25-foot-deep well was dug at the southeast corner of the public square to hold water for the fire company's use. T. H. Stagg (kneeling, third from right) was the first president of the Hook and Ladder Company.

The Hillsboro Coffee Club was organized on March 3, 1894. The club was initially formed to serve refreshments to the volunteer firefighters as an alternative to their visiting the several saloons downtown. The club also used this house to provide farmers' wives and children a place to rest during their visits to town since they would not go to the saloons.

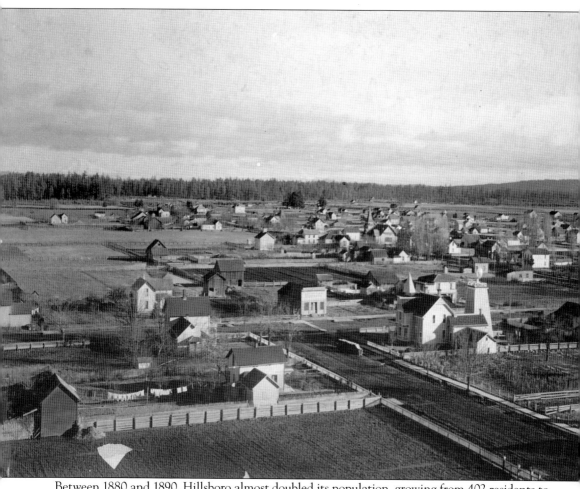

Between 1880 and 1890, Hillsboro almost doubled its population, growing from 402 residents to 800. This panoramic view of the city from the 1890s was taken from the new water tower, looking east and south. The explosive growth of the 1880s resulted in the construction of numerous wood-frame houses, each with its own large fenced garden and pasture area, plus a handful of new

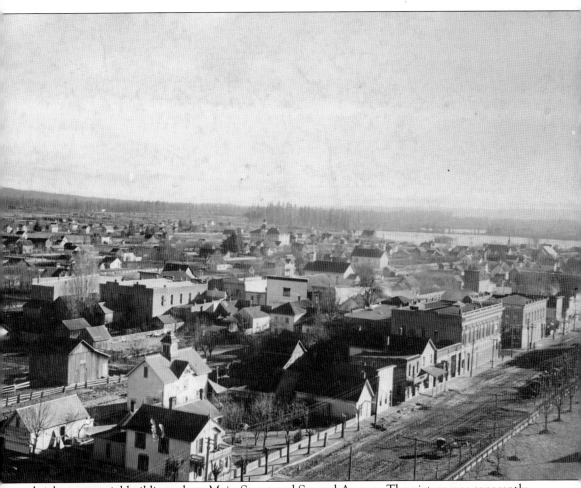

brick commercial buildings along Main Street and Second Avenue. The picture was apparently taken in the spring; trees at the courthouse, in the foreground, are not yet in leaf, and the waters of Mirror Lake, now known as Jackson Bottom, can be seen to the right at the edge of the city. Cooper Mountain is on the horizon.

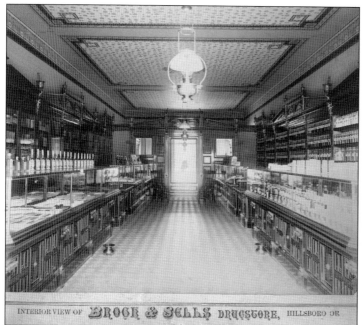

Broch and Sells Drug Store, one of the earliest businesses downtown, became Delta Drug in 1890. The Delta operated one of the first telephone exchanges in town with 37 subscribers, and public telephone service was also available. An article in the local newspaper noted, "Grant Hughes has placed an instrument in the Delta Drugstore and the public can talk to Cornelius and Forest Grove for just 15¢." The exchange was moved to Hoyt Jewelry in 1898.

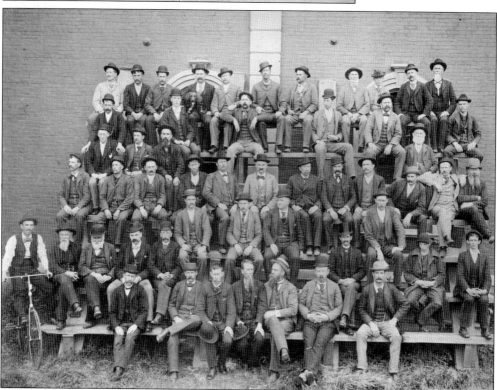

By the 1890s, the downtown commercial district had grown to 35 businesses. City leaders and businessmen, like those shown here on the risers in front of the courthouse, were no longer tolerant of Hillsboro's "Sin City" reputation, and 11 city ordinances regulating public behavior in town were passed during this period. (Courtesy of Mary Stafford.)

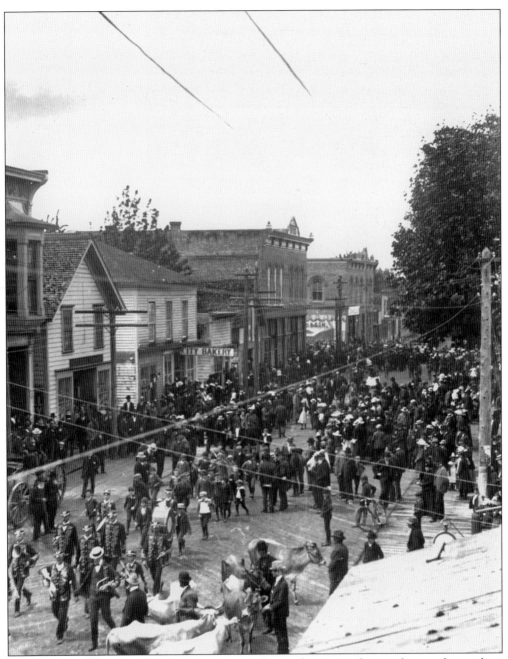
Hillsboro's newly planked Main Street provided a much-improved route for parades, such as this one in the 1890s, which combined the artistic excitement of the brass band with the agricultural element of the prized cows in the foreground. Boys and girls participated in the march down Main Street. Events such as this demonstrated that the city was evolving quickly from its rowdier past.

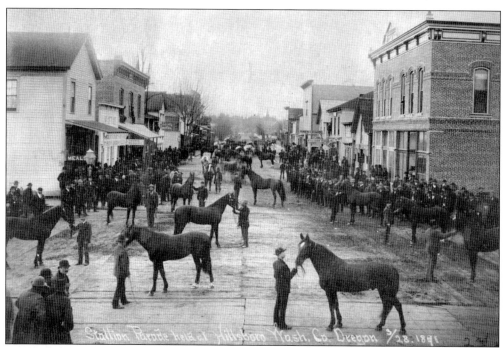

Although the business community was growing dramatically, agriculture was still the foundation of the city's economy. Pictured here is the 1891 Stallion Parade at Main Street and Second Avenue. Horse shows and fairs were held at this location for many years. Such events provided local farmers an opportunity to show off their horses and purchase new ones.

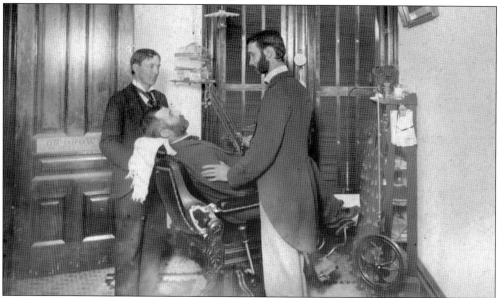

By the 1890s, Hillsboro had a dentist's office on the second floor of the Morgan and Bailey Building at Second Avenue and Main Street. Just behind the dentist is a canary in a cage. Like the proverbial "canary in the coal mine," this bird was used by the dentist to ensure that he and his patients were safe during the use of nitrous oxide in some procedures. Pictured from left to right are Warren Dobbins, William Dewitt Smith (patient), and Dr. C. B. Brown (dentist).

F. A. Bailey, with Schulmerich and Son, constructed this brick building in downtown Hillsboro in 1890, and it was occupied by one of Hillsboro's dry goods and hardware stores. Francis Bailey had been a medical cadet in the Confederate army and was a leading medical doctor in the community. He also served three terms as mayor. Dr. Bailey called on patients throughout Hillsboro and extended his house calls even to surrounding Washington County.

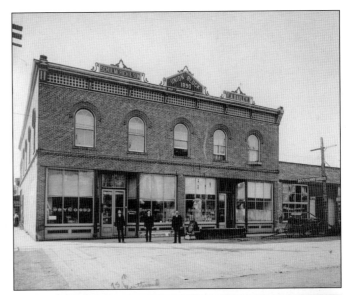

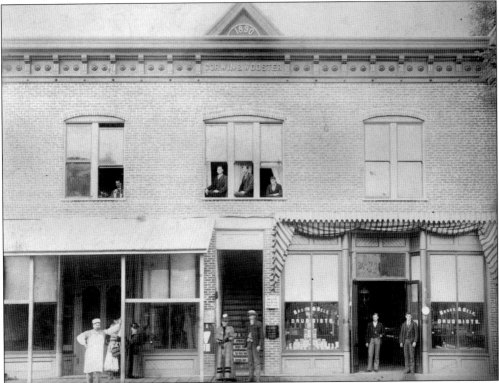

Several prominent brick buildings were constructed after the creation of the 1890 downtown fire district, including the newly updated courthouse and the new city hall and fire station at Washington Street and Second Avenue. Private buildings included the Morgan and Bailey Building at Second Avenue and Main Street; the Central Block at the same intersection; and the Union Block north of Main Street between Second and Avenues. Henry Wehrung, who built the first hotel in town, constructed the Wehrung Block building, shown here, near the Union Block on the north side of Main Street between Second and Third Avenues.

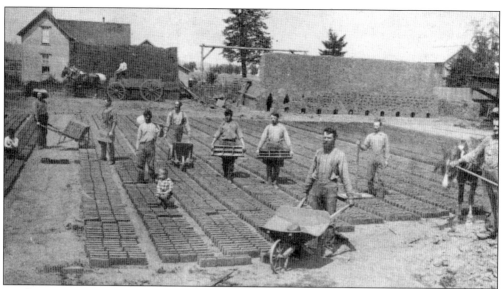

Fertile Tualatin Valley clay soils could also be formed into bricks and clay tiles. Joe Adams operated this brickyard in the 1880s near Fifth Avenue and Oak Street. He later moved his brickworks to Sewell Grove, now known as Shute Park. These bricks provided material for many of the downtown buildings. Producing bricks and tiles for construction was a thriving business for several companies in the Hillsboro area at the beginning of the 20th century. (Courtesy of *Hillsboro Argus*.)

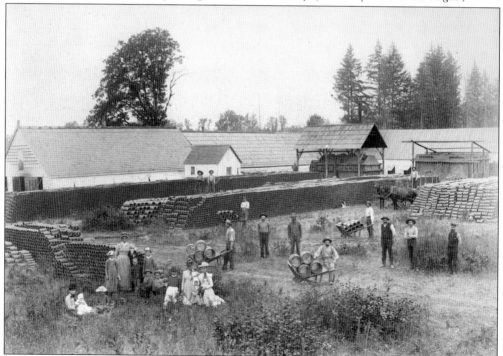

James Sewell operated the North Pacific Clay Works near the present intersection of Evergreen and Sewell Roads, northeast of Hillsboro Airport. Circular clay tiles were made in different diameters for a variety of uses like irrigation, drainage, and sanitary sewers. Sewell's tile company was the largest in Oregon at one time.

James Henry Sewell is shown in this picture with his wife, Sarah Allen, and three children, James A., Alice (standing), and Mary (baby). Sewell owned 740 acres just north of Hillsboro. The Sewell and Imbrie families lived not far from each other and worked and played together. James Sewell was also the founder of the local grange.

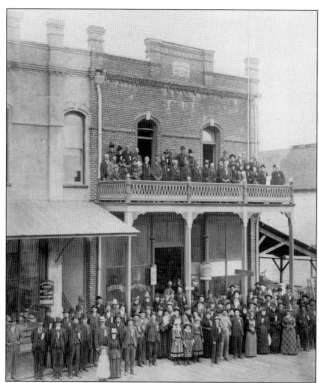

Established in 1874, Hillsboro Grange No. 73 is the seventh oldest of the 276 granges in Oregon. The first grange convention pictured here was held in 1891 in Hillsboro. The Grange Hall was located on Second Avenue and Main Street. Granges across the United States provided local farmers a unique opportunity to work cooperatively in buying farm equipment, selling crops, and sharing information on the latest scientific agricultural methods.

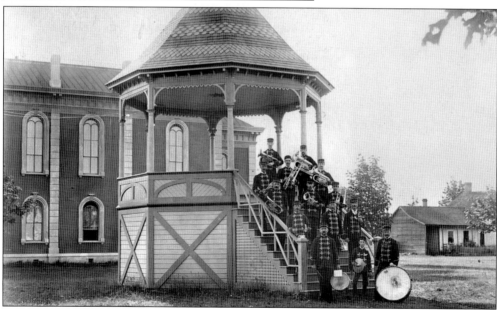

A bandstand was constructed in the 1890s on the courthouse grounds so the Hillsboro Brass Band, also known as the Hillsboro Men's Band, could perform outdoor concerts. The band also performed indoors in the Opera House above McKinney's Livery on Second Avenue. Established in 1876, the Opera House was an entertainment center and meeting hall for the community. Traveling dramatic groups and musicians would perform there until the Crescent Theater opened in 1906.

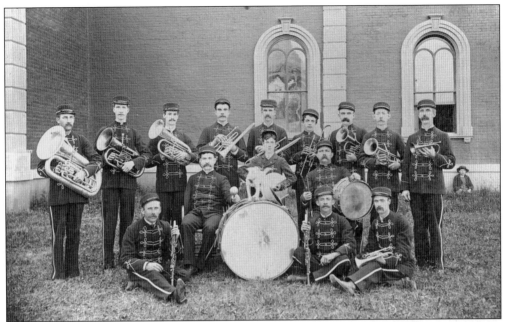

The Hillsboro Brass Band, pictured here in front of the courthouse, played in parades, fairs, and concerts. The band was originally established in 1875. Longtime resident May Ringle Lepschat recalled for the *Argus* when she played in the northeast corner of the courthouse lawn during a band concert, dancing and keeping time to the music, out of sight behind the trees.

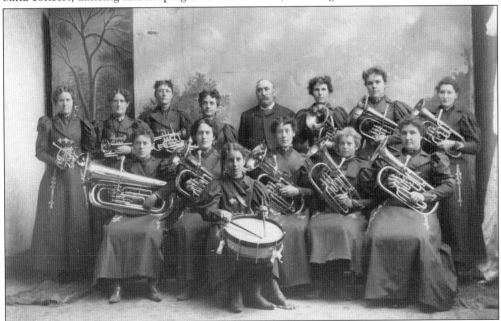

Hillsboro also had a women's brass band separate from the men's band but often led by the same conductor. The *Hillsboro Argus* noted that women in Hillsboro continually made their mark on the town: Emma McKinney became the owner and manager of the *Argus* itself; Ida Becker was one of the first women to fly in an open cockpit airplane; and Lucia Zora controlled a carload of elephants at the Sells Floto Circus that came to town in 1912.

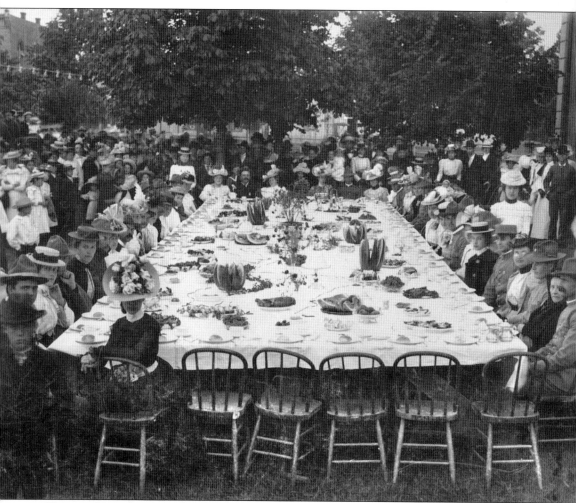

The courthouse lawn was the site of other community celebrations, such as this banquet in 1899 in honor of Spanish-American War veterans. In 1898, U.S. president William McKinley called for local volunteers for duty on the battleship *Oregon*, which sailed around Cape Horn and joined the U.S. fleet off Cuba. Local troops later left for Manila on three ships in the summer of 1898. On August 17, 1899, the *Argus* invited all Washington County residents who had served in the war to attend a "royal welcome back" to Hillsboro. The huge banquet was the grandest ever seen in the city.

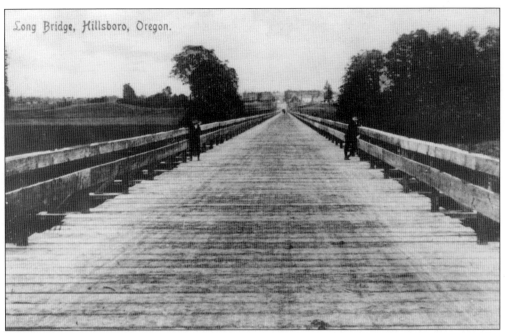

In the 1890s, the Long Bridge was built over Dairy Creek on the road to Forest Grove, now the Tualatin Valley Highway. When the bridge was built, the road connected to Main Street, but in 1919, the Hillsboro City Council rerouted it two blocks south of downtown. As noted in the *Argus*, Hillsboro businessmen were concerned that travelers would not see the best the town had to offer. Mayor John Wall suggested that signs be put up directing people to the business section two blocks north.

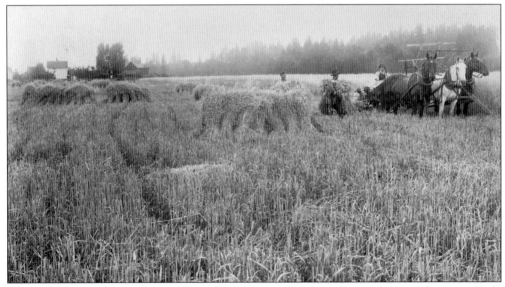

On the Hartrampf farm, workers drove horse-drawn threshers during the grain harvests. Early farm size was regulated by the 1862 Homestead Act, which allowed each settler to claim 160 acres. In 1880, there were 785 farms in Washington County, averaging 219 acres in size. Farmers soon began dividing their farms, first to help their children get a start in life and later to help themselves financially. By 1900, the average farm size in Washington County had decreased to 87 acres.

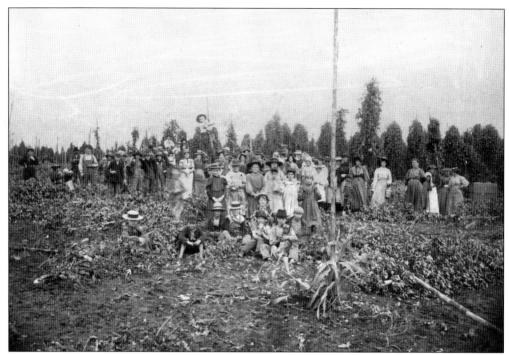

Hops, used to make yeast and beer, were a common crop in the Tualatin Valley around Hillsboro. The vines grew up cords strung on wooden frames, and picking hops offered entire families, including children, a chance to earn money and work together during the summer. Hops were an important local crop until the early 1920s, when a mildew blight decimated the fields, since there were no chemicals yet available to fight the disease.

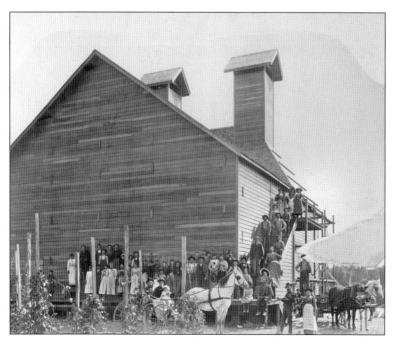

Several Washington County farmers had their own hop dryers—large barn-like sheds with special towers to vent the hot air from fires built on the ground floor to dry the hops on the second floor. Many of the people who picked hops by hand at the valley farms would travel from far distances and lived in tents on the farms throughout the short season.

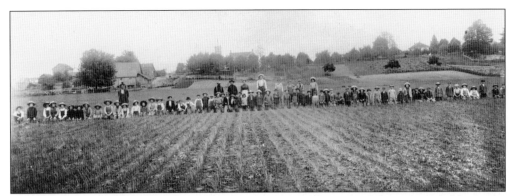

The Corrieris, an Italian family, established an onion farm south of the city, probably on the northern edge of Mirror Lake, now Jackson Bottom. Several other Italian families established similar onion farms in Washington County in the late 1800s.

Another popular local crop was berries. John Holmason (third row, fourth from left, wearing dark suit) and his family picked berries in the Orenco area. The Holmasons were one of the Hungarian families the Oregon Nursery Company had recruited to move to Oregon to work at the nursery. Berry farming and picking sometimes supplemented the families' incomes from the nursery.

As Hillsboro grew more family oriented, the number of children warranted a larger school than the existing buildings at Third Avenue and Baseline Street. In 1888, property on Oak Street between Fourth and Fifth Avenues was purchased from Mr. and Mrs. Henry Wehrung for $1,100.

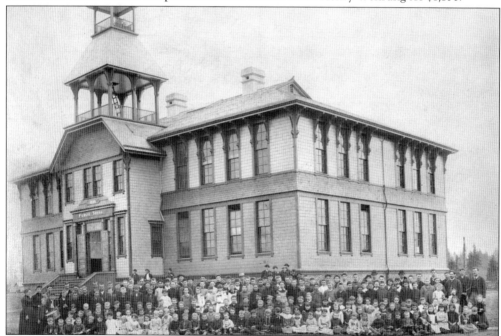

The handsome new school on the former Wehrung property was built in 1889. It had eight rooms and a two-level bell tower. Classes were first held there in the spring of 1890. The older school building at Third Avenue and Baseline Street, including the original 1853 log section, later burned. (Courtesy of Mary Stafford.)

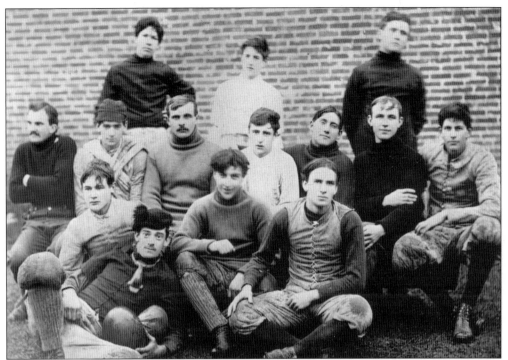

Then and now, Hillsboro boys enjoyed sports. The 1897 Hillsboro football team, pictured above, included Frank Stewart, E. Burke Tongue, John Bailey, and Adrian Merryman. The second row includes Art Shute, Thomas H. Tongue Jr., John Moore, and other boys from prominent and long-established Hillsboro families.

A vacation at the beach involved a major trip taking several days either over the Coast Range or down the Columbia River. The neighboring Sewell and Imbrie families, for example, traveled three days on the Wilson River Road to reach Netarts-by-the-Sea. In this photograph, taken in Long Beach, Washington, Bertie Tozier (left) and Edith Tozier (center) are pictured in their bulky bathing attire complete with caps and black stockings. Nellie Tozier sits at far right.

As the Washington County seat, Hillsboro attracted more than its share of attorneys. One of the most prominent was Thomas Tongue, whose law offices were located upstairs in the new brick building at the southwest corner of Second Avenue and Main Street across from the courthouse. This building, with its distinctive, angled corner entry, remains standing today and is known as the 1890 Building.

Thomas Tongue was president of the Hillsboro Board of Trustees and was mayor twice, from 1882–1883 and again from 1886–1887. In 1890, he chaired the Republican state convention, and in 1896, he was elected to the U.S. House of Representatives, where he served three terms before his death in 1903. His son, Edmund Tongue, was also an attorney. Edmund Tongue's Craftsman Bungalow house is located on the south side of West Main Street between Bailey and Connell Avenues.

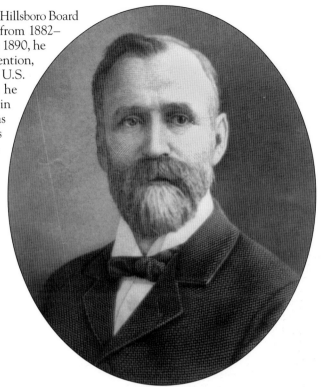

In 1885, the Washington County Agricultural Society sold the County Fairgrounds site, 50 acres west of downtown, to Thomas Tongue. The fair had been held there since 1870. Tongue held horse races on the property for many years. Pricemont, pictured here on the track, was one of Tongue's prize racehorses.

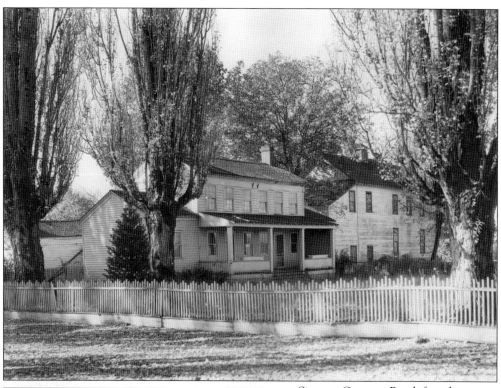

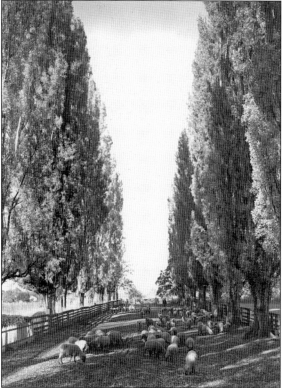

Simeon Gannett Reed, founder of Reed College and a wealthy Portland businessman, had a summer home and a racetrack built on his large farm, south of what is now Tualatin Valley Highway. His wife, Amanda, spent more time on the farm than her husband did, and the farm managers probably occupied the house, pictured above.

Simeon Reed and William Sargeant Ladd, another wealthy Portland businessman, established the Ladd-Reed Farm Company on the 800-acre Nathan Robinson homestead between Hillsboro and Beaverton in the late 1800s. The Ladd-Reed Farm became famous for its prize-winning horses and imported Cotswold and Leicester sheep. In 1889–1890, Ladd and Reed platted an area north and east of their headquarters for residential development, and the neighborhood built there became known as Reedville.

Four
Hillsboro Grows Up

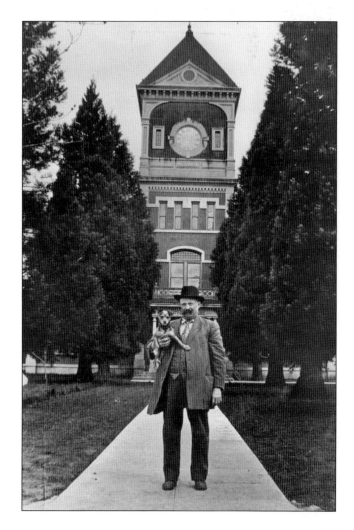

At the beginning of the 20th century, Hillsboro was reinventing itself. The population had grown to 980 people, and laws restricting vagrancy, noise, and drunk and disorderly behavior were now strongly enforced. Police chief ? Blaser, shown here in front of the courthouse with his watchdog, also served as the city engineer and had the responsibility for turning the electric streetlights off and on. Blaser was also the sanitation inspector, checking septic tanks until the city got its first sewer system in 1911.

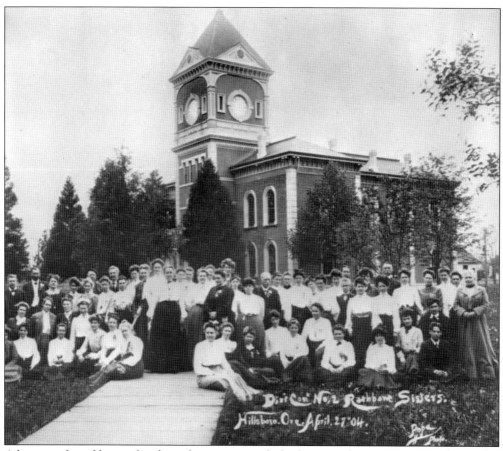

A large number of fraternal and social organizations for both men and women sprang up during this period, including the Rebekah Lodge women's auxiliary of the International Order of Odd Fellows, and the Knights of Pythias and its women's auxiliary, the Pythian Sisterhood. The Pythian Sisters later became the Rathbone Sisters of the World, whose Hillsboro members are pictured above on the courthouse lawn. Members were wives and daughters of prominent Hillsboro businessmen.

The Hillsboro Brass Band continued to provide entertainment for parades and festivals in Hillsboro, and was invited to give concerts in other locations, such as a Democratic rally in Portland. Hillsboro's civic pride was flourishing, and city leaders sought to make their city known to a wider audience. In 1904, community leaders sponsored an exhibit at the Lewis and Clark Centennial Exposition in Portland.

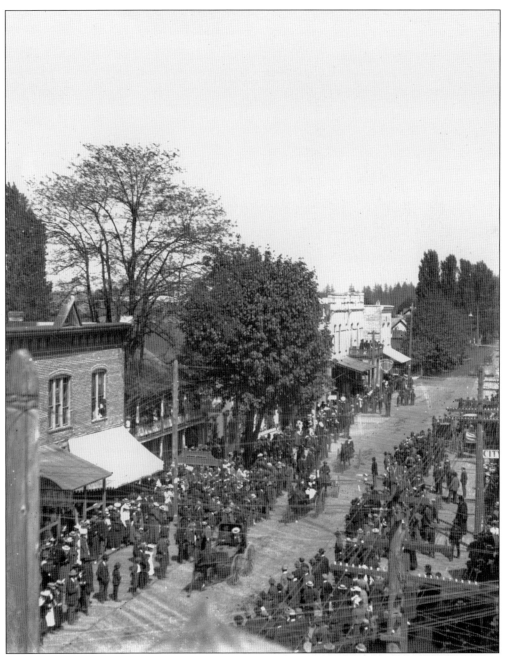

Hillsboro residents enjoyed many types of community events and gatherings, usually centered in the downtown area, such as this horse race on Main Street. The web of new electric and telephone lines was a contrast to the aging Tualatin Hotel, located behind the large tree in the center of the picture. Residents were determined to leave Hillsboro's past behind and change their "Sin City" image. On November 4, 1913, six years before the Volstead Act ushered in Prohibition across the country, Hillsboro citizens voted to outlaw the sale of alcoholic beverages within the city limits.

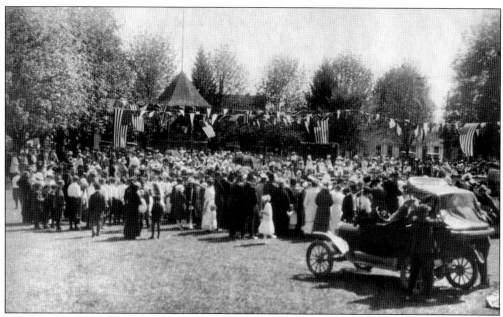

Banker John Shute offered Sewell's Grove to the City of Hillsboro for a park in 1906. He sweetened the offer with his willingness to accept a lower price if the city would name the park after him. Some community gatherings, like this 1916 spelling bee, were moved from the courthouse lawn to the newly created Shute Park.

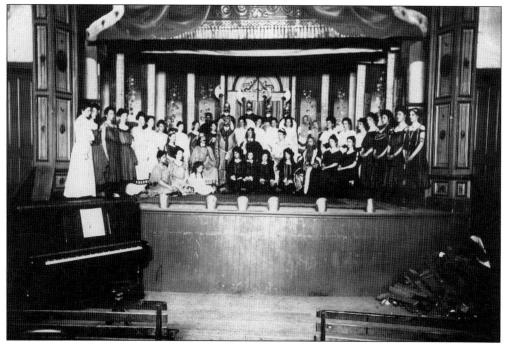

The Crescent Theater opened on February 22, 1906, at the corner of First Avenue and Main Street. Five hundred people attended the opening night. Entrepreneur Orange Phelps, who operated the Arcade Movie House on Main Street during this period, also acted as booking agent for the Crescent. It later inherited the title of Opera House from the earlier facility above McKinney's Livery.

Mary Ramsey Wood was reportedly born on May 20, 1787, near Knoxville, Tennessee. Mary married Jack Lemons in 1804 and had four children. After Lemons died, she moved to Oregon in 1853 and married John Wood in 1854. John and Mary Ramsey Wood ran the Commercial Hotel at the corner of Second Avenue and Washington Street, the present site of the HART Theater. In 1907, Mary Ramsey Wood celebrated her 120th birthday in Hillsboro by taking an automobile ride with an unidentified woman, James Imbrie, and Dr. Elmer Smith (shown below). At the time of her death in 1908, she was reputed to be the oldest woman in the state of Oregon and possibly in the United States. Her headstone reads "First Mother, Queen of Oregon Pioneers." January 1, 2008, was proclaimed Mary Ramsey Wood Day by the City of Hillsboro in celebration of the 100th anniversary of her death.

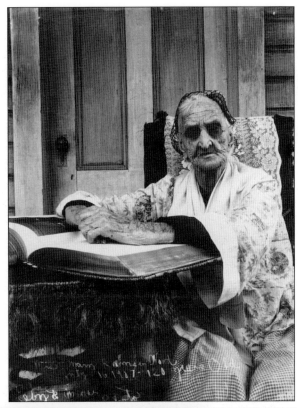

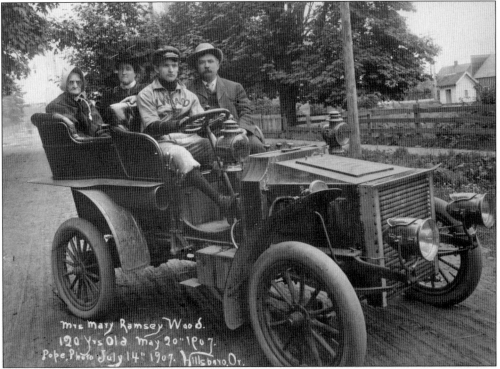

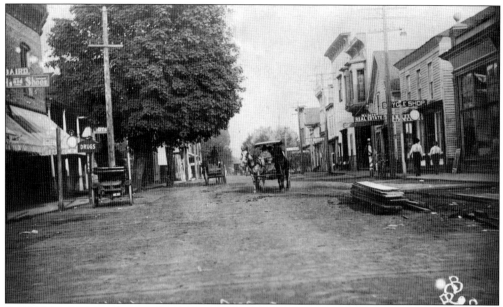

By 1908, horse-drawn buggies had begun to share the streets with early automobiles in downtown Hillsboro. But preparation had begun for another mode of transportation with an even greater impact at the time. Wooden planks were removed from Washington Street to allow for the laying of interurban train tracks. In this picture, similar planks, visible in the right foreground, were also being removed on Main Street.

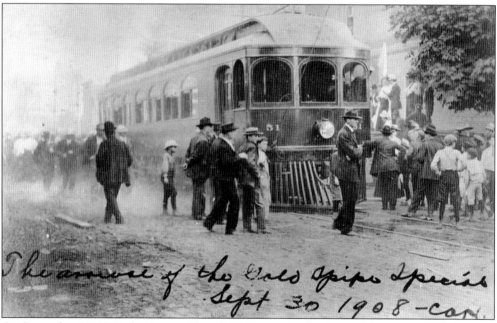

On September 30, 1908, the Oregon Electric Railway arrived at Second Avenue and Washington Street amidst great fanfare and celebration. The handwritten caption on this photograph reads, "The Arrival of the Gold Spike Special." Oregon Electric railcars had dark green painted exteriors. The interiors featured seats with velvet upholstery and wood-trim finishes. Some trains even had parlor cars manufactured by the famous Pullman Palace Car Company.

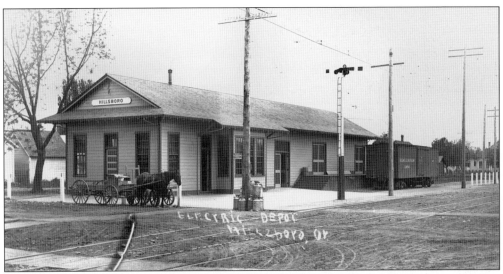

The Oregon Electric Railroad ran between Hillsboro and Portland in much the same way that MAX trains provide service today and on exactly the same alignment in Hillsboro. Then, as now, the trip to Portland took about an hour, a vast improvement on the still-primitive roads and automobiles. The electric railroad was cleaner and quieter than the earlier steam trains, making it attractive and comfortable for regular business commuters and families.

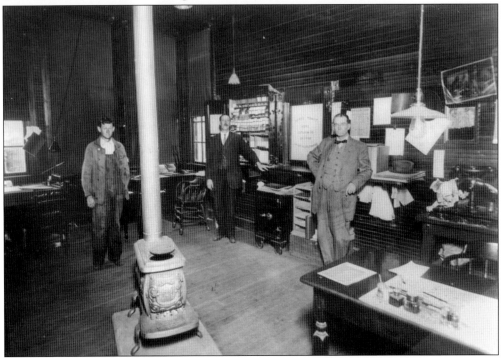

Inside the Oregon Electric Depot at Third Avenue and Washington Street, travelers could buy tickets for the six daily trains. There were 11 stops between Hillsboro and Portland, and the fare was $1.15 for a round-trip. A morning nonstop express was added later, as well as an owl run at midnight for Hillsboro and Washington County residents returning late at night from cultural and social events in Portland.

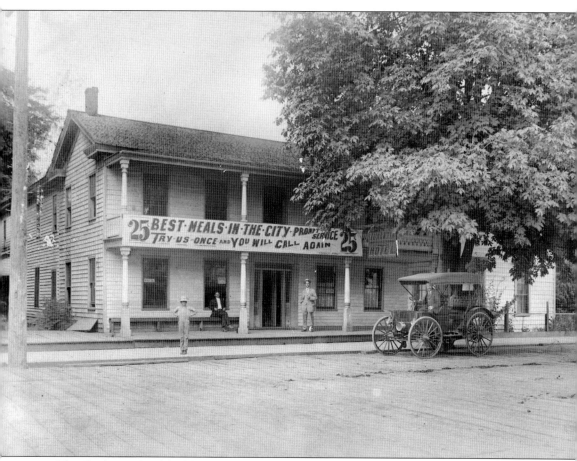

The Tualatin Hotel had been one of the earliest businesses in Hillsboro and continued to thrive until the construction of a new hotel in 1911. Local physician James P. Tamiesie built the Washington Hotel on Main Street, which opened on February 22, George Washington's birthday. Located on the southeast corner of Main Street and Third Avenue, and said to be the finest hotel west of Portland, the Washington soon became serious competition for the older Tualatin Hotel. The first floor had business offices, shops, and a beautiful lobby. The second floor was reserved for women lodgers, but the third floor was for all guests. Each room had hot and cold water, and each floor had several baths and toilets, a true luxury at the time.

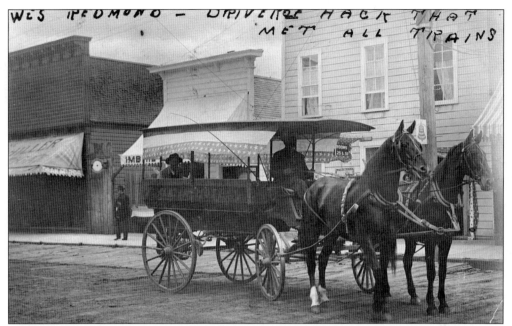

The Tualatin Hotel did have a popular amenity that the Washington Hotel may have lacked. This horse-drawn hack taxi met both the heavy rail and the interurban trains, and provided transport directly to the hotel. In this photograph, the Tualatin Hotel hack is driven by Wes Redmond. For travelers' convenience, tickets for the trains could be purchased at the Tualatin Hotel office.

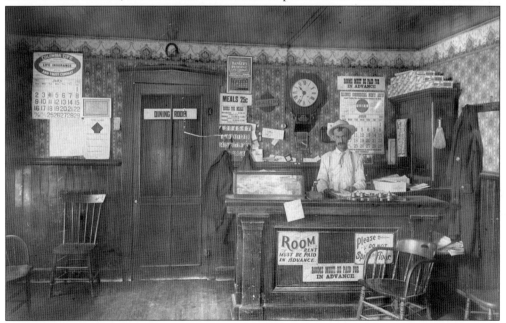

The office of the Tualatin Hotel in 1911 was a modest place. Owner John Foot is behind the desk in this photograph. The new Washington Hotel at Third Avenue and Main Street, which opened in 1911 and was known for its beautiful lobby and amenities such as hot and cold water in each room, soon outpaced the older Tualatin, which was torn down in 1919 and replaced by Weil's Department Store.

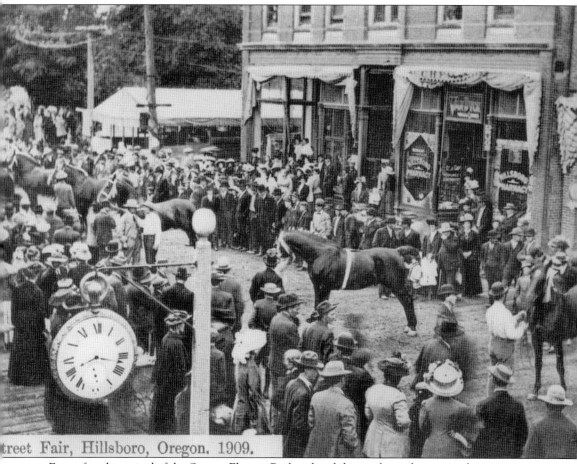

Street Fair, Hillsboro, Oregon. 1909.

Even after the arrival of the Oregon Electric Railroad and the resulting changes in the community, some traditions, like the Stallion Parade on Main Street in 1909, stayed the same. Showing, breeding, and racing horses remained popular with wealthy residents. Thomas Tongue's Oregon Kid was one of the greatest steeplechasers in the West, winning every race he entered.

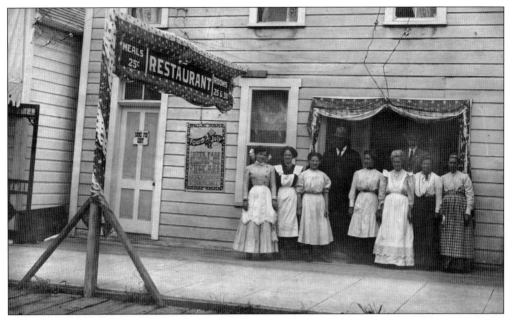

Several new restaurants opened up downtown, competing with the hotel eateries. This one offered meals for the same price as the Tualatin Hotel, with rooms upstairs for 25¢ and 50¢. In a 1911 postcard, Mabel Fuller noted that her parents had 13 regular boarders in the rooms upstairs. It was common at this time for personal photographs to be converted into postcards for mailing to friends. Hillsboro's Johnson Photography Studio would do this for a small fee.

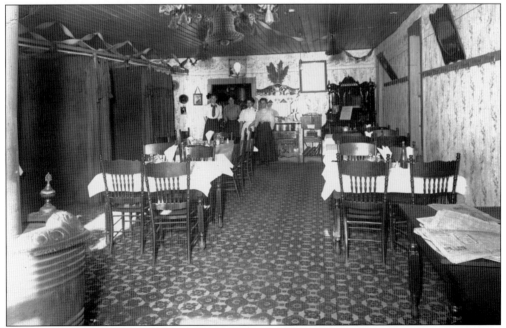

Another postcard photograph from Mabel Fuller shows the interior of her parents' restaurant that, as she explains, they bought in 1910. This restaurant and others reflected the higher quality of dining and services now offered to visitors to Hillsboro. These civilized establishments were quite a departure from the frontier town saloons that were all Hillsboro had to offer a few years before.

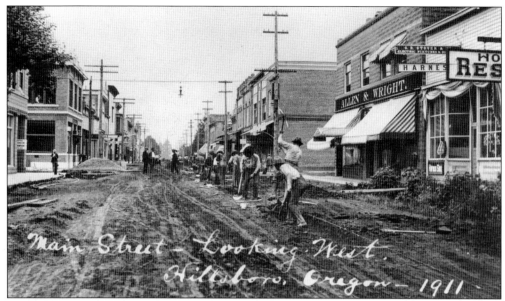

In 1911, Hillsboro began paving its downtown streets. These workers are digging up Main Street east of Third Avenue in preparation for the new asphalt. That year, Mayor George Bagley requested that the city's debt limit be raised to $100,000 to finance public projects, such as the downtown paving and improvements to the water system.

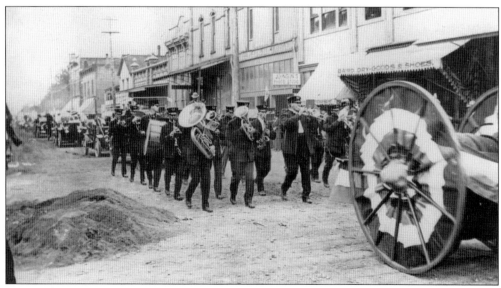

Despite the inconvenience of the roadwork, parades along Main Street continued, with this band marching around piles of dirt in the middle of Main Street. The band is marching east, between Second and Third Avenues, sometime in 1911. Johnson Photography Studio is to the left of the Baird Store, and the fire department's fire hose reel, festooned with bunting, is on the right.

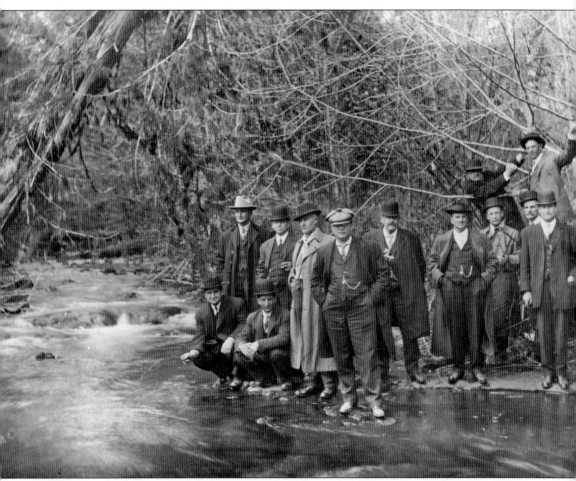

Hillsboro obtained water from the City of Forest Grove for many years. At that time, water storage consisted of two 30,000-gallon tanks, 75-feet tall, at Third Avenue and Lincoln Street. The Hillsboro leaders pictured here found a new water source for the city at Sain Creek, 17 miles southwest of the city. Two new concrete reservoirs were completed in 1913 ten miles southwest of town, each of which could hold 1,250,000 gallons of water. Twelve-inch wooden pipes connected the reservoirs to the distribution system throughout the community. The leaders' foresight was an indication of the future; the capacity of Hillsboro's current water system is a major factor in its role as a center for high tech industry almost a century later. Pictured from left to right are (kneeling) Wesley W. Boscow and Bob Hartrampf; (standing) Emil Kuratli, Harry Bagley, Judge W. D. Smith, George Bagley, William Barrett, Art Shute, Bruce Wilkes, unidentified, Al Long, and Bill Pittenger (in the tree).

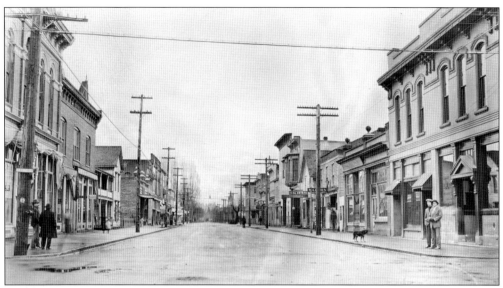

By 1912, Main Street paving and concrete sidewalks were completed downtown. The number of residents had nearly doubled in the past 10 years. Hillsboro's population was now up to 2,014. The front page of the *Hillsboro Argus* on May 18, 1911, showed "Billy Hillsboro" shedding his short knickers and school jacket, and putting on a grown man's business suit. Hillsboro was ready to grow up and become a mature, responsible community.

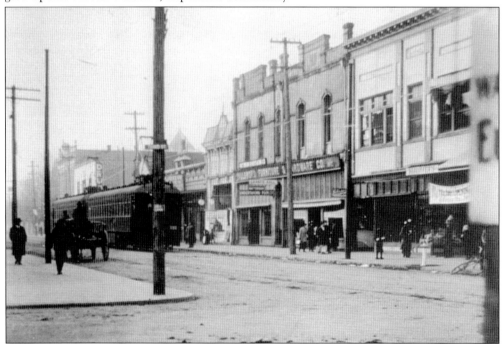

Also by 1912, downtown Hillsboro had a second interurban rail line. The Southern Pacific Railroad offered service east to Portland and west to Forest Grove and Tillamook. Southern Pacific was granted a franchise to run tracks on Main Street with a stop on the north side of Main between Second and Third Avenues. The Southern Pacific trains, known as the "Red Electrics," competed with the Oregon Electric line until the 1930s. (Courtesy of Ruth Klein.)

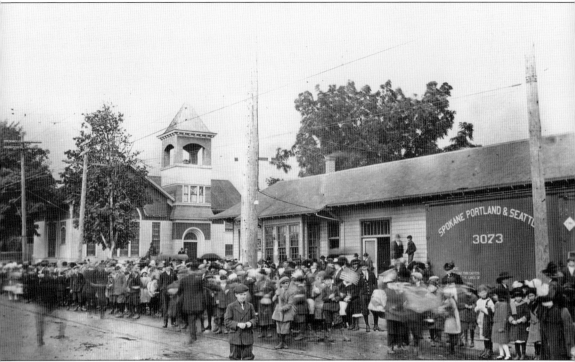

Community events also benefitted from the improved transportation. Schoolchildren in this picture are waiting for a special Oregon Electric train to take them to the Washington County Fair in Forest Grove. Until it found its permanent home, the fair was sometimes held west of Hillsboro just outside Forest Grove. The Craftsman Methodist Church can be seen in the background.

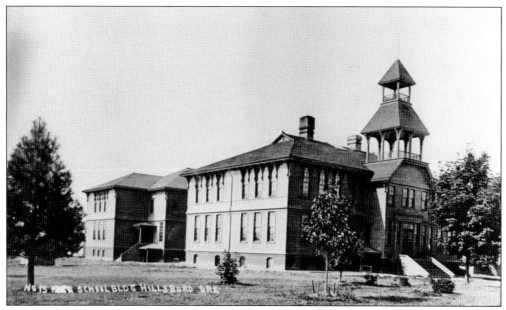

In 1909, due to increases in the school population, a $48,896 contract was awarded to Stephen Holland to expand David Hill School at Fifth Avenue and Oak Street, and add six new rooms. The addition is on the left, behind the original school with its two-level bell tower.

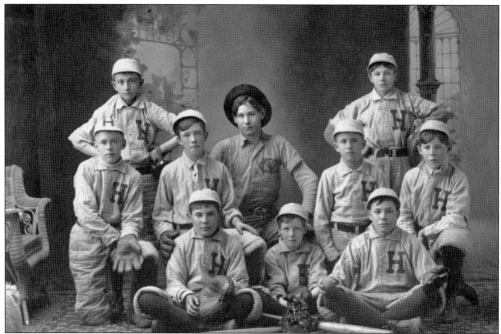

Ralph Ireland (in the center with the round-brimmed, dark hat) was the manager of the boy's baseball team in 1908. His family later started Ireland's True Value Hardware on Main Street and Third Avenue. Pictured in uniform with him are, from left to right, Peck Broughton, Verne McKinney, and Ward Wilkes in the front row. Kneeling behind them are, from left to right, Bill Nelson, Robert Imbrie, Clifford Long, and Lynn Ballard. The two boys standing are Kenneth Humke (left) and George Humke.

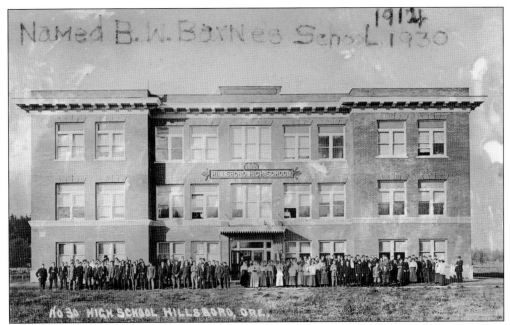

A new high school, which cost nearly $160,000, was constructed in 1912. Located north of downtown on Third Avenue, south of Grant Street, it was known as the North School. The building at Fifth Avenue and Oak Street, on the site of the David Hill School, was known as the South School. The North School became the B. W. Barnes Middle School 17 years later, after another new high school was built.

The E. L. McCormick Store in downtown Hillsboro sold a wide range of goods, everything from bicycles to pencils. As noted in the September 15, 1904, *Argus*, "Every school girl and boy attending Hillsboro public school will receive free a lead pencil and a pencil tablet at E.L. McCormick's, beginning Saturday and continuing one week." Pictured here are E. L. McCormick (right) and an unidentified man.

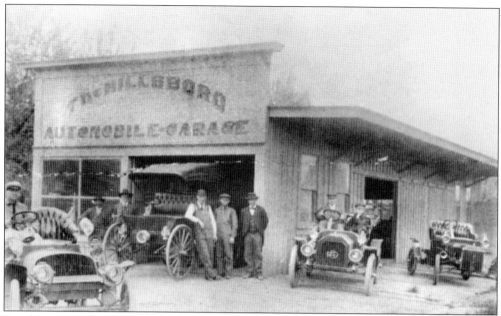

In addition to the interurban trains, another innovation—the automobile—transformed transportation in Hillsboro during this period. Another new business, the Hillsboro Automobile Garage, opened to service the new machines, as shown in this picture from 1910. While automobiles and horses now traveled together on local streets, the more traditional mode of transportation did not completely give way to the automobile until the 1920s.

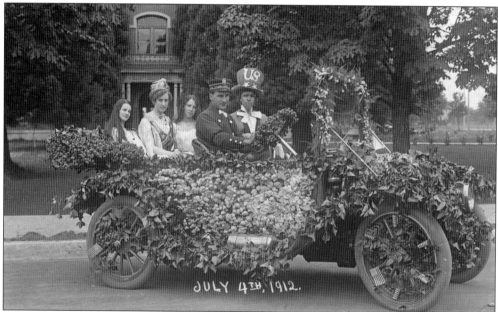

Automobiles began transforming local celebrations as early as 1912. In the Fourth of July parade that year, Uncle Sam rode as a passenger in an automobile float driven by a uniformed chauffeur. The automobile, including the wheel spokes and steering wheel, was transformed with festoons of flowers and ivy. Although motorcars were gaining popularity, the railway was still the favorite mode of transportation. (Courtesy of Mary Stafford.)

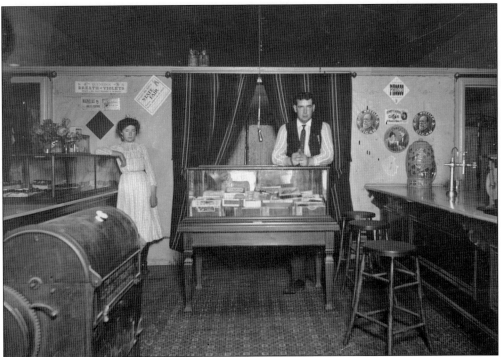

In 1907, Lorne Palmateer (right) and his sister Geneva (left) took over operation of the telephone exchange previously operated in Delta Drug and Hoyt Jewelry. By then, the number of subscribers had grown from 37 to 250. Geneva Palmateer Mitchell recalled that the switchboard was operated using a pole changer to ring all the numbers. Later in life, Mitchell was known throughout the community for giving college scholarships to less fortunate girls graduating from Hillsboro High School.

Jerome Palmateer and his son Lorne opened Palmateer's Confectionery on the west side of South Second Avenue. The store later moved to Main Street. The Palm, as it became known, provided downtown shoppers and visitors with sweets through the early 20th century.

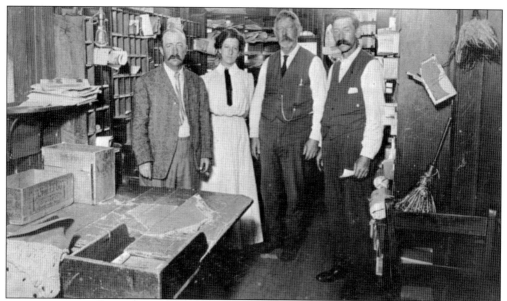

In 1912, the post office was located at Third Avenue and Main Street. Post office staff in this picture includes postmaster Benjamin Cornelius and a Mr. Holznagel. The March 18, 1915, *Argus* stated, "It is now confidently expected that the [post office] department at Washington may order free City delivery for Hillsboro Mail by midsummer . . . It will require at least two carriers to handle the delivery as there is a great deal of territory to cover." (Courtesy of Mary Stafford.)

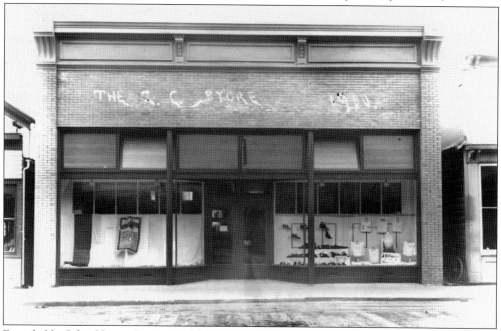

Founded by John Henry Garrett and his wife, the CC Store downtown opened in 1909. It had been named for Carter and Carter of Vancouver, who financed the Garretts' retail venture. After opening on Second Avenue, John Garrett later moved the store to 270 East Main Street and operated it there until his death. Even after his passing, the CC Store remained downtown until 1962, when it was moved to the Sixth Avenue Plaza.

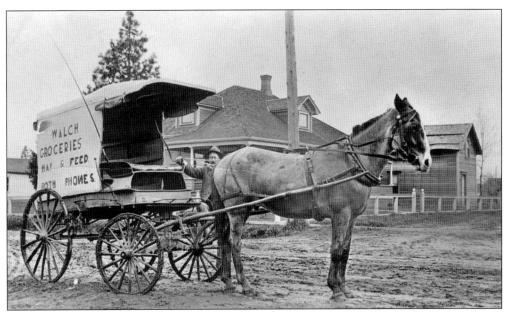

Mr. and Mrs. Fred Walch first came to Hillsboro in 1908. The Walch Grocery was located on First Avenue, and the Walch family made their home at the back of the store. Home grocery delivery was provided to store patrons using this horse-drawn delivery wagon. Fred Walch is pictured above with his wagon.

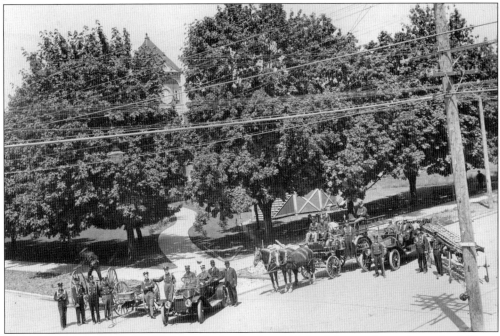

By 1914, the fire department consisted of a chief and 20 firefighters who each received $2 per month compensation. The department had a 60-gallon water wagon drawn by two horses, a hose wagon, and two hand-drawn hose carts. For taller buildings, the department also had a hook-and-ladder truck. The Sanborn Fire Insurance map of 1912 noted that the fire horses worked on the street part of the time and were stabled at the firehouse at night.

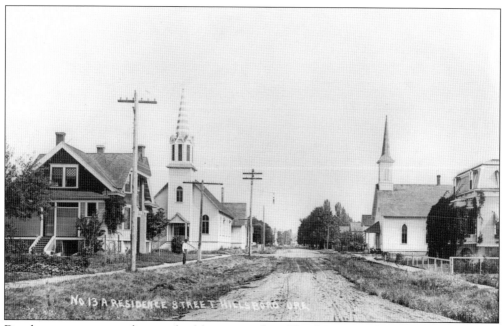

Development was expanding south of downtown along Third Avenue. This picture was probably taken looking north on Third Avenue, just south of Walnut Street. The picture shows the St. Matthew's Catholic Church with its decorative spire on the left and a more modest church on the right, perhaps the old Hillsboro Baptist Church, now the Knights of Columbus Hall. The house in the left foreground may be the grand Albert Sholes House, constructed in 1905.

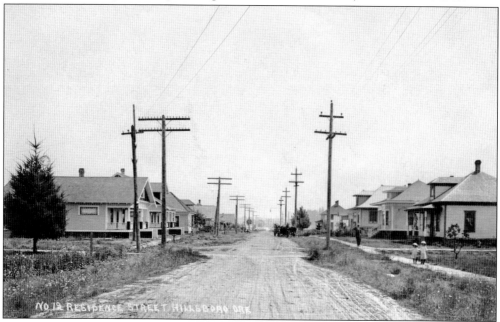

The city's population more than doubled between 1900 and 1910, from 980 citizens to 2,016. In the resulting housing boom, residences were built at a furious pace to keep up with the demand. Many of the houses were constructed in the common residential styles of the period. These bungalows were located along Jackson Street, just north of downtown Hillsboro.

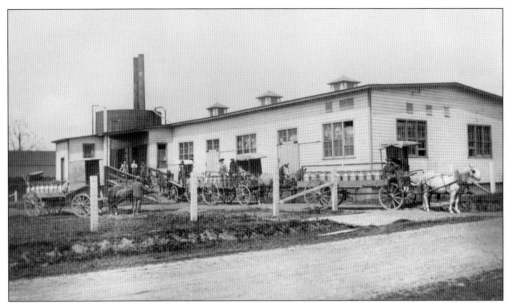

Carnation Milk established its sixth condenser plant in the Pacific Northwest in Hillsboro in 1907. Five years earlier, Carnation founder Elbridge Stuart had established a plant just outside of Forest Grove. The Hillsboro plant was located at the foot of South First Avenue, just north of Jackson Bottom.

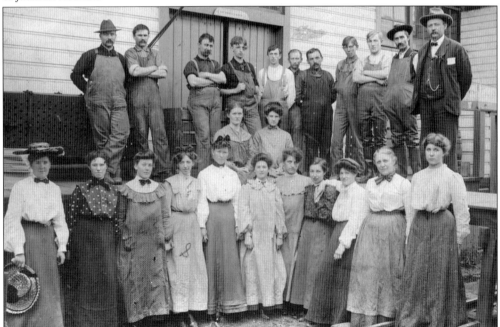

Carnation employed the local workers shown here, and dairying soon became a major income for local farmers. Most dairy farmers belonged to the Dairy Cooperative Association, which had a contract with Portland distributors. The distributors had promised to pay 8¢ per quart of milk but tried to get out of the high-priced contract during the Depression. The Carnation plant also lowered payments for the dairy farmers, who struggled to make ends meet. Eventually, the farmers declared a "milk war" and began pouring their raw milk onto the ground.

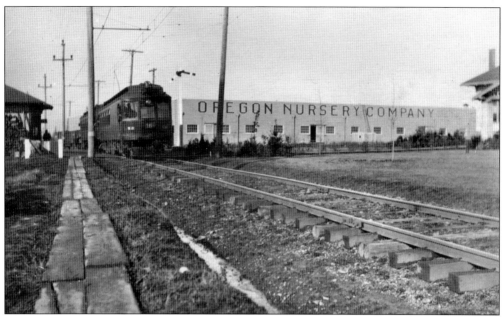

Orenco was established in 1905 as a company town for the Oregon Nursery Company, whose holdings included roughly 1,133 acres south of Cornell Road between present-day 231st Avenue and Cornelius Pass Road. Company officials negotiated with the Oregon Electric Railroad for a right-of-way through the nursery's property. One of the nursery's large packing sheds constructed near the railway is shown in this picture.

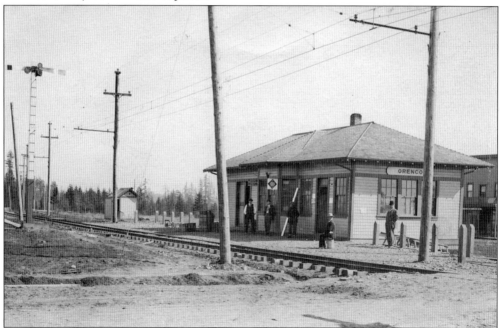

The Oregon Electric Railway established a train stop at Orenco in 1908. From there, it took eight minutes to reach Hillsboro and 45 minutes to reach Portland. Convenient railway access made it much easier for residents of Orenco to shop and sell produce in downtown Hillsboro and Portland, and to enjoy the amenities of the larger communities.

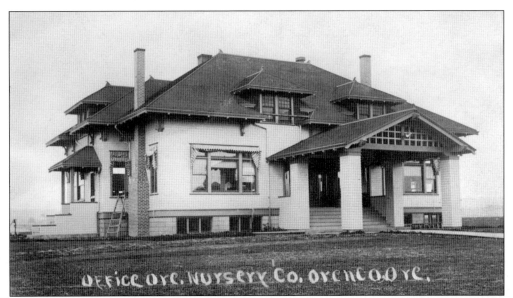

The nursery office, constructed in 1907 north of the rail line and east of the packing sheds, had a modern interdepartmental telephone system to serve approximately 20 office staff and more than 100 outside salesmen. The Oregon Nursery Company was operated by Malcolm McDonald and his partner, a Canadian Scot named Archibald McGill. McGill's house, the first building constructed in Orenco, still stands on the north side of the MAX alignment between 227th and 228th Avenues. (Courtesy of Ruth Klein.)

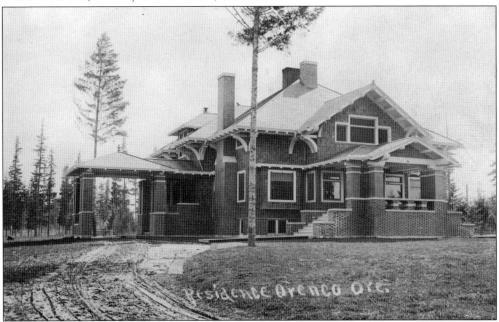

Malcolm McDonald and Archibald McGill originally established the Oregon Nursery Company in Salem. After a disastrous fire in the late 1800s, McDonald began looking for a new site, chose the area east of Hillsboro, and moved the operation. McDonald had this house constructed in 1907 east of the main Orenco town site. The house still stands on the former Orenco Woods Golf Course property.

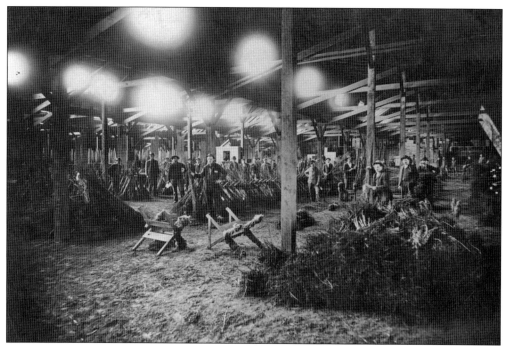

This picture shows the interior of one of the Oregon Nursery Company's large packing sheds, which was 87,120 square feet (almost 2 acres) in area. This building was so large it was used several times to hold the Washington County Fair. Inside the packing shed, skilled nurserymen packed fruit trees, nut trees, shade trees, berries, and other nursery stock for shipping.

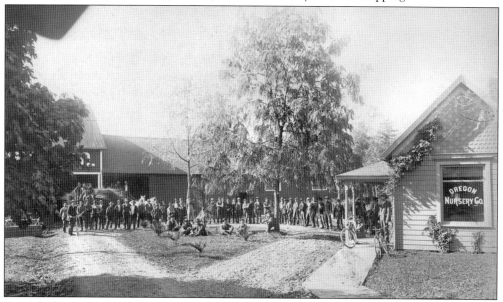

Several Hungarian families immigrated to America to work at the Oregon Nursery Company. Their homes were built southeast of the Orenco town site on what is now Quatama Road. Some of the houses from the original Salem site were lifted off their foundations and moved north to this new location. McGill and McDonald had platted an entire community for the workers and their families, and most workers lived in the newly constructed homes.

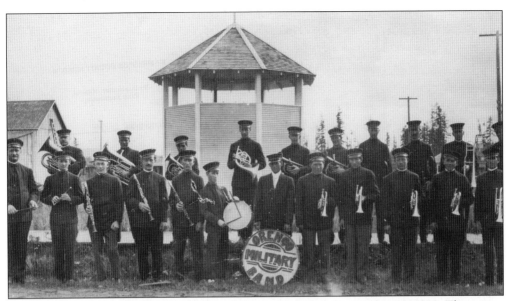

The Orenco Military Band, pictured here, was established on September 18, 1913. There were originally 21 members. As in Hillsboro, the local band was important to the community and played at festivals, parades, and other community events. The Orenco town site had a central green, laid out in a similar fashion to Hillsboro's public square around the courthouse, where the Orenco band would often play.

By 1910, there were 500 residents living in Orenco. The town had its own school, a fire station, a town hall, stores, a post office, and a hotel. H. V. Meade began a printing operation there in 1911 to publish catalogs for the company and the town paper, the *Orenco Herald*. The city incorporated in 1913. Its original street names, which remain today, reflected its nursery heritage: Alder, Birch, Chestnut, Dogwood, Elm, and Fir.

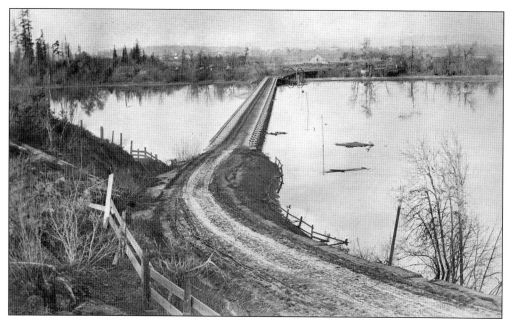

On the back of this picture, dated March 1923, someone wrote, "In the good old days bridges spanned Jackson Bottom south of the Tualatin River." The first bridge across Jackson Bottom was built in 1905. Farmer Henry Tilson and others complained that the stench from an old open sewer pipe at Jackson Bottom was so bad he would not even run his pigs there. It was clear that the city needed a new sanitary sewer system.

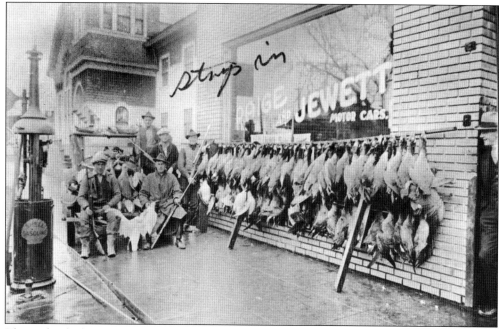

The wetlands along the Tualatin River at Jackson Bottom attracted thousands of waterfowl during the spring and fall migrations. Hunters like these killed ducks and geese indiscriminately. The area has now become the Jackson Bottom Wetlands Preserve, recognized statewide for its wetlands and wildlife conservation and education programs.

Five

THE ROARING TWENTIES, DEPRESSION, AND WAR

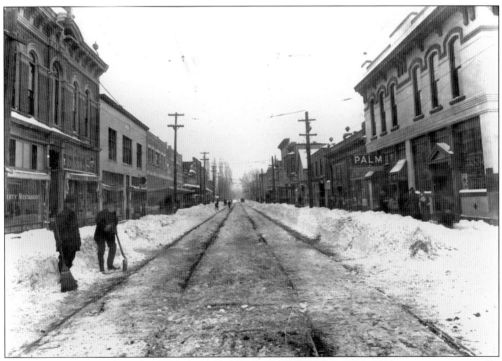

Hillsboro's growth slowed substantially in the second decade of the 20th century, especially between 1915 and 1920. The 1920 census showed a population of 2,468. This photograph shows the Red Electric tracks on Main Street being cleared of snow to allow the trains to travel into downtown. Although the interurban trains operated through 1930, the automobile was gaining popularity, and the railroad companies began investing in the construction of local roads.

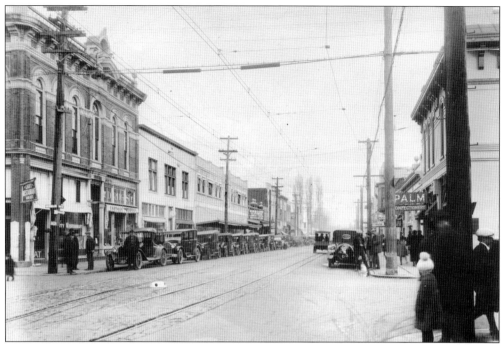

While commuters still regularly used the interurban rail lines to travel to Portland and neighboring towns, many residents could now afford to purchase private automobiles, as is evident in this photograph. Reliance on the rail lines waned, and the Red Electric service was eventually discontinued in 1930.

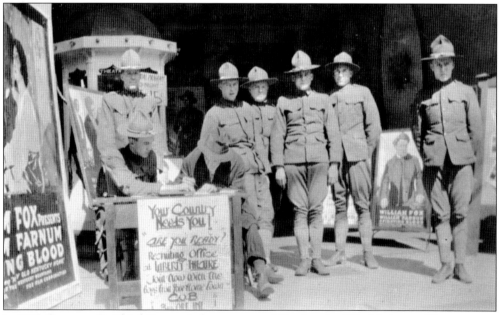

In 1917, Company B, Third Oregon Infantry was mobilized as the 162nd Infantry. The company recruited at a table on Main Street in front of the theater. Hillsboro leaders convened at the Crescent Theater to declare their support for the war. Under the Selective Service Department, the county seat of Hillsboro had its own draft board, which held its first draft on May 18, 1917.

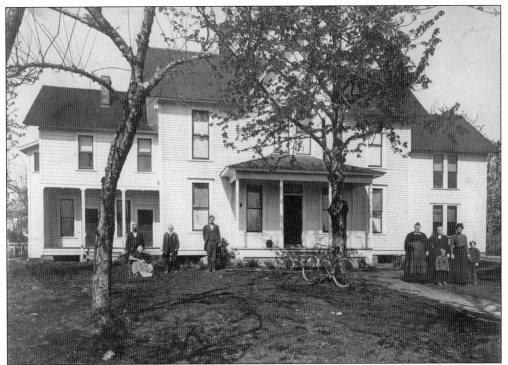

Indigent and destitute individuals were given medical care at the County Poor Farm, located southeast of Hillsboro near the present location of the Bonnie Hayes Animal Shelter. Dr. J. O. Robb directed the county home, and Minnie Jones managed it. Cattle, chicken, and vegetables were raised there for residents' meals and occasionally to be sold. This structure burned down in 1920.

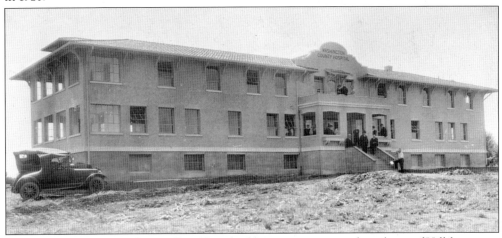

In 1923, a new two-story County Poor Farm building was constructed southeast of Hillsboro near the present location of the Bonnie Hayes Animal Shelter. The new building could accommodate 60 patients. Two smaller "pest houses" behind the main building were used to isolate contagious patients, and a small cemetery was located nearby. This building was used as a hospital until 1950, when it became the Washington County Extension Office. The county hospital building was demolished in 2001, and a memorial and a small park on the former cemetery site were established in 2002. (Courtesy of Oregon Historical Society, CN 014997.)

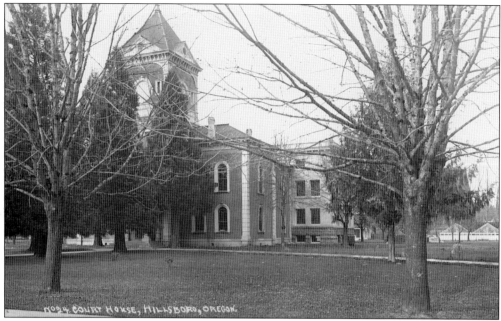

In this photograph, the 1912 addition to the county courthouse is on the south side of the old courthouse, immediately behind the Porter Sequoias. In 1928, the 1872–1891 courthouse was demolished, but the 1912 addition was retained and is still used today. The new courthouse faced Second Avenue and had a temple-front entry built in a classical Greek style, including fluted columns with curled capitals and lion heads on the entablature above the columns. (Courtesy of Ruth Klein.)

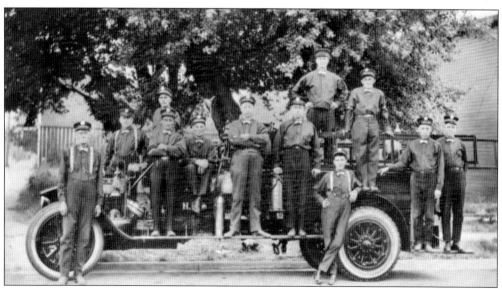

On July 20, 1922, the city purchased a new fire truck to replace the horse-drawn wagon and hose carts used for many years. Walter Tews, pictured here in the driver's seat with his legs crossed, was the fire chief from 1928–1935. (Courtesy of Mary Stafford.)

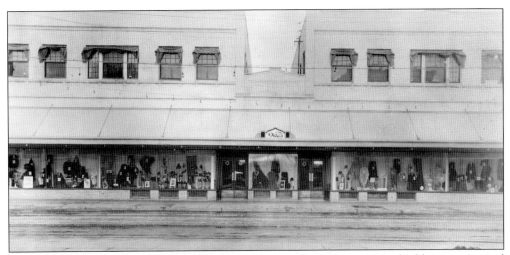

In 1919, the Tualatin Hotel was demolished to make way for a new two-story building constructed by Nathan Weil. The building became Weil's Department Store, which continued operating downtown for several decades. After an alteration that opened a first-floor walkway north from Main Street to the parking area south of Lincoln Street, the building is now known as Weil's Arcade. (Courtesy of Mary Stafford.)

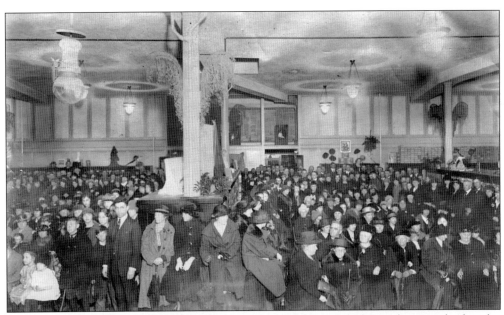

Weil's Department Store provided residents with a full line of clothing, shoes, and other dry goods, and was a local shopping destination in the days before shopping centers and malls. As a promotional event, store management would often host fashion shows, such as this "style show" in 1922. (Courtesy of Mary Stafford.)

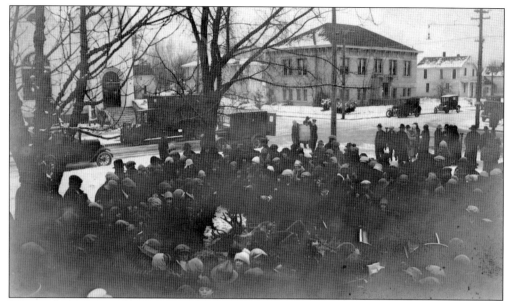

Seen in the background of this picture, a Carnegie Library was built at Second Avenue and Lincoln Street in 1914 on land donated by Dr. Samuel Linklater. Dr. Linklater was killed by a train while on a house call shortly thereafter, and his widow, Zula, built a double-wall concrete house next door, which still stands on Second Avenue. In the foreground is a Christmas celebration sponsored by the *Argus* in 1924, where reindeer were displayed on the courthouse grounds.

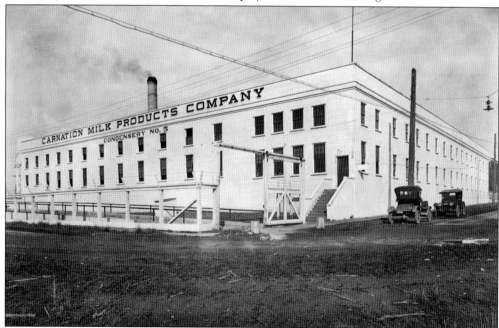

On September 14, 1914, the Carnation Milk Company announced plans to spend between $20,000 and $30,000 to enlarge its existing plant into one of the largest on the West Coast. The success of the expanded plant resulted in Washington County becoming a leader in the Oregon dairy industry. In 1948, the milk plant on South First Avenue was converted to manufacture Friskies Dog Food using horse meat and skimmed milk.

Impresario Orange Phelps came to Hillsboro in 1908 and converted a Main Street storefront into the 108-seat Arcade Theater. In 1913, Phelps bought the old Shute Bank Building and converted it to the Liberty Theater. He also operated the Majestic Theater from 1916 to 1917. His grandest Hillsboro theater was the Venetian, shown here under construction in 1925–1926 on the Liberty Theater site. Phelps showed first-run American movies here until 1956, when the interior was gutted in a fire.

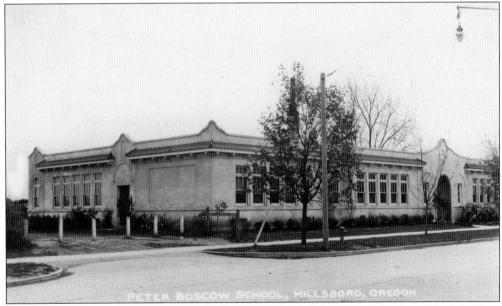

In 1922, an elementary school was built adjacent to the B. W. Barnes School on Third Avenue, south of Grant Street. The new school was named for Peter Boscow, who had served on the board of education from 1900 to 1914. Boscow came from Britain. His house still stands at the northeast corner of Main Street and Seventh Avenue. When it was built in 1891, it was almost a mile from the city limits and was surrounded by a dairy farm.

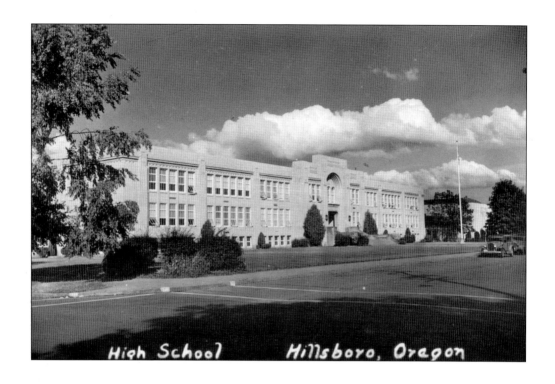

The new Hillsboro Union High School was dedicated on May 6, 1929. Constructed in the art deco style for $175,000, it was located north of NE Jackson Street between Sixth and Ninth Avenues. In the fall of 1929, high school students began attending the grand new high school. Middle school students in grades six, seven, and eight were transferred to the old "North School," which was renamed the B. W. Barnes Middle School. The photograph below shows new teachers at B. W. Barnes in 1930.

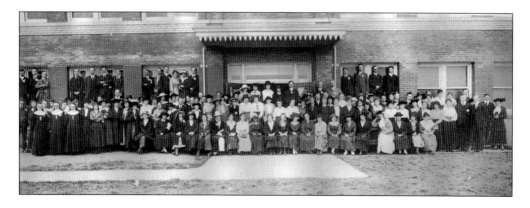

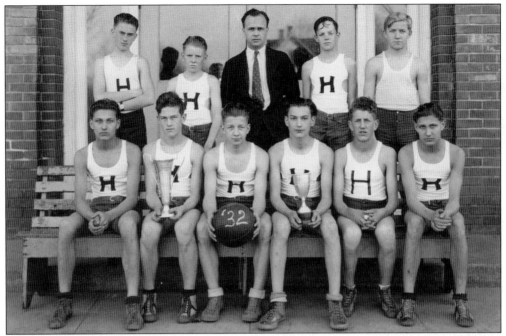

The high school students quickly settled into their new facility and formed sports teams. Pictured above is a boys' basketball team from 1932. The Hillsboro High School basketball team went to the state finals five times during the 1940s and made it to the semifinals in 1949.

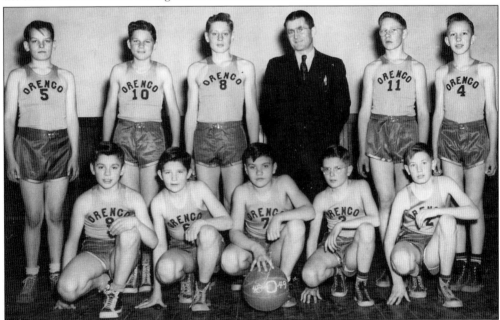

The Oregon Nursery Company began losing money during the Great Depression, filed for bankruptcy, and was dissolved in 1927. Businesses and residents departed during this time, and the city government was dissolved in 1938. But students continued to attend the Orenco School. Pictured here is the Orenco Grade School basketball team from 1949. Orenco resident Earl Engebretson is No. 8. (Courtesy of Earl Engebretson.)

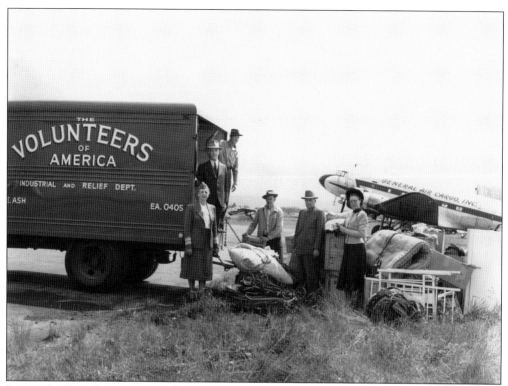

During the Great Depression, U.S. president Franklin D. Roosevelt's Works Progress Administration (WPA) built a new post office at Fourth Avenue and Main Street. WPA workers were housed at the David Hill School, and Civilian Conservation Corps camps were established just outside of town. They helped build major roads like Wolf Creek Highway, completed in 1941 and later renamed the Sunset Highway. Groups such as the Volunteers of America, pictured above, distributed clothing and supplies to the unemployed.

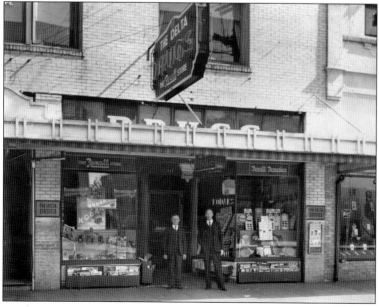

The Delta Drug Store opened in the 1890s and provided local residents with over-the-counter remedies that benefitted many. During the Great Depression, when people had no health insurance and no money to pay doctors, they would often go to drugstores like Delta Drug to discuss their ailments with the pharmacist.

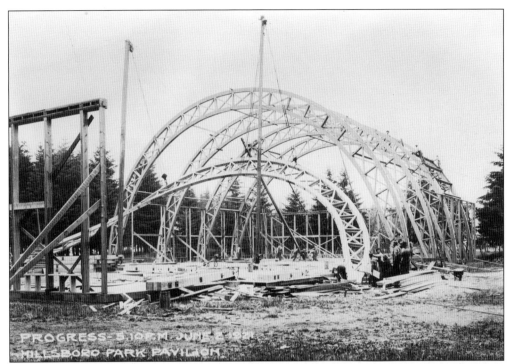

Orange Phelps spearheaded construction of the Shute Park Pavilion in 1921. Located on the south side of Maple Street at Ninth Avenue, the pavilion had a fine maple floor, perfect for roller skating. This facility replaced Hillsboro's first skating rink, which had opened in 1908 above a feed store on First Street. (Courtesy of Mary Stafford.)

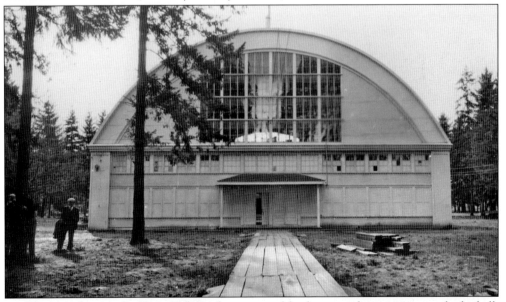

In addition to skating, the Shute Park Pavilion was used for dances and sometimes even basketball. The pavilion was demolished in 1974 to make room for the new Shute Park Library, but its stone and concrete entrance walls can still be seen on both sides of the library's parking lot entrance from Maple Street.

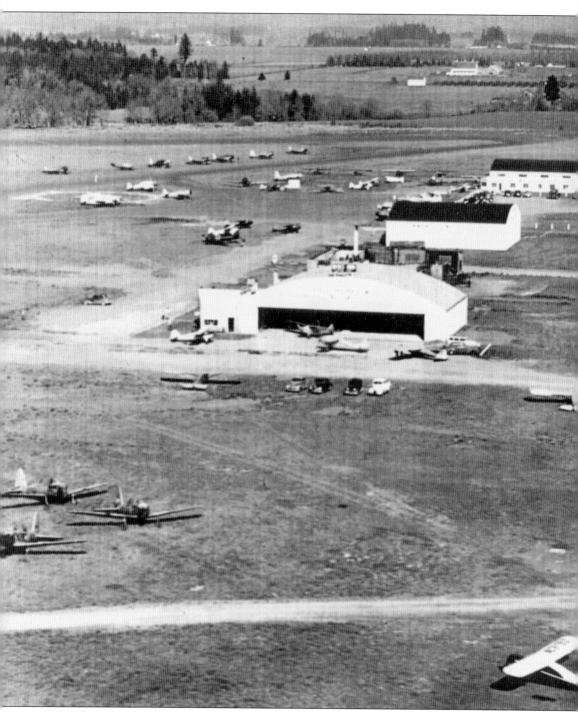

Dr. Elmer Smith bought 100 acres of the Hawthorn Estate in 1928 to construct a private airfield. American Legion Post volunteers prepared turf runways, and local businessmen underwrote an air circus later that year. During the Great Depression in 1933, the local businessmen formed a partnership with the city that allowed the expenditure of nearly $25,000 in WPA funds for otherwise unemployed men to improve two 3,000-foot runways. In November 1938, Hillsboro

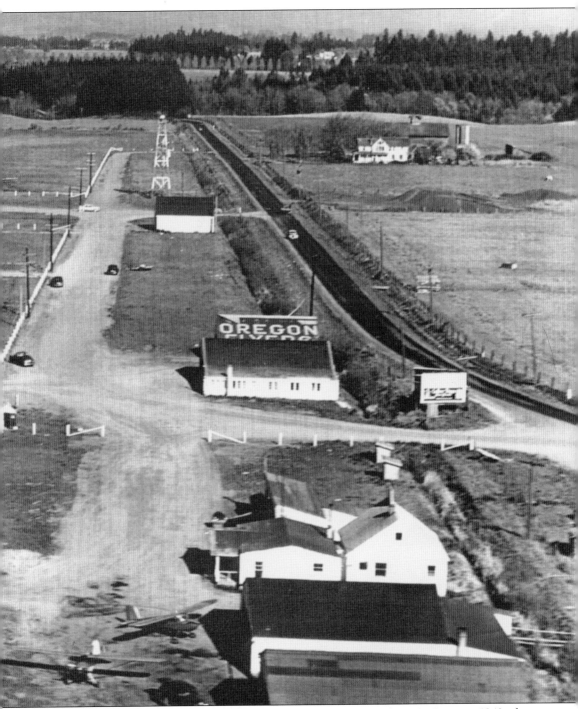

voters authorized the expenditure of $7,500 to purchase the property. In January 1942, the federal government offered Hillsboro more than $366,000 for improvements to the airport as a national defense project; Hillsboro voters approved a municipal bond to supplement the project. The Hillsboro airport was used little by the military and returned to civilian use in 1945. Cornell Road is seen in the upper right in this 1940s photograph.

In February 1939, Edward Ball, president and representative of the Hillsboro Aviation Club, leased the airfield from the city. Ball and the aviation club refurbished existing hangers and built several new ones. By 1940, there were three hangars and an office building, and approximately 100 students had received flying lessons from Ball, the first licensed instructor.

Norman "Swede" Ralston (in the center of this photograph) became the second licensed flight instructor at the Hillsboro Airport, having taken a special course to become certified as a civil flight instructor. By 1940, Ralston owned two of the seven airplanes stored in the hangars at the Hillsboro Airport. (Courtesy of Dana McCullough.)

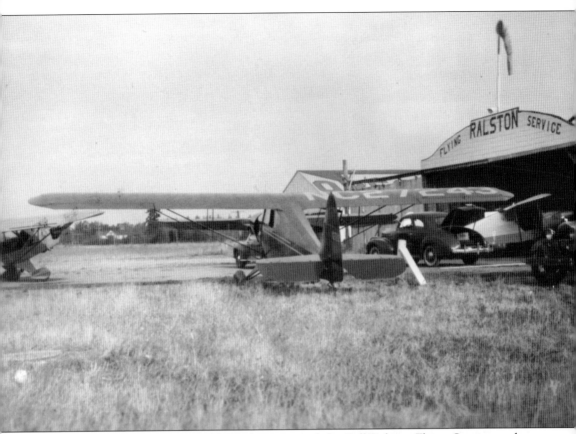

Later in the 1940s, Norman "Swede" Ralston opened the Ball-Ralston Flying Service at the Hillsboro Airport. Flying was not a lucrative profession, and Ralston and Ball ran booths at local events such as Happy Days and sold private flying lessons and airplane rides for $1. Taxiways were still grass during this period. (Courtesy of Dana McCullough.)

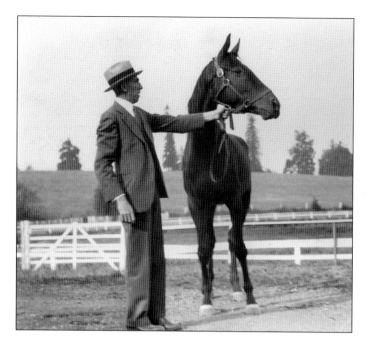

Harold Wass Ray and his father started a food processing plant in 1920 that later became the Ray-Mailing Cannery and then Birdseye Frozen Foods. In 1933, Ray purchased more than 400 acres east of Hillsboro from Rachel Hawthorn, established a racetrack, and began raising thoroughbred racehorses. Ray was also instrumental in the creation of Portland Meadows, a racetrack in Portland. A modern subdivision near the former Ray estate is called Sunset Downs in recognition of Ray's racetrack.

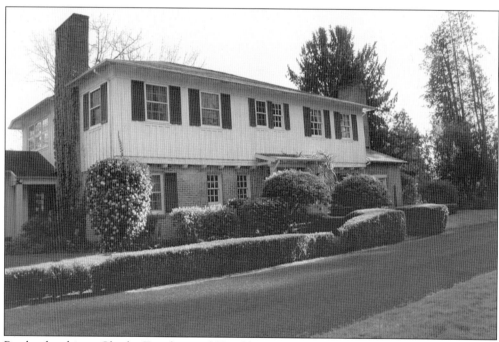

Portland architect Charles Ertz designed Harold Wass Ray's country estate, Hawthorn Farm, in 1935. The house, which still stands east of the Hawthorn Farm Intel campus, is a blend of prairie style and farmhouse architecture. The interior was richly adorned with Spanish Colonial arts and crafts furnishings, an open staircase, and a pegged oak floor. The Ray house, shown in this recent photograph, was listed on the National Register of Historic Places in 1994.

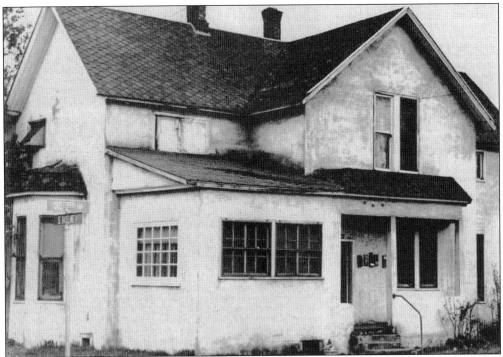

In 1920, Minnie Jones opened a hospital in a house at Seventh Avenue and Baseline Street. She had previously worked with Dr. J. O. Robb in his office and at the County Poor Farm. When Robb was called up for military service in 1917, Jones took over his administrative duties at the hospital. Dr. Archibald Pitman, who lived in Archie McGill's former house in Orenco, was also one of the physicians at her first hospital. (Courtesy of *Hillsboro Argus*.)

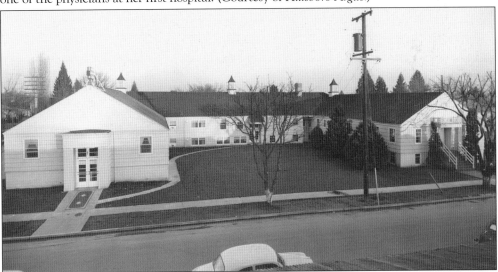

Minnie Jones constructed a new hospital in 1940 at a cost of $23,000. The larger facility was located across Baseline Street from the old hospital on property now occupied by the Tuality Community Hospital. In addition to 28 patient rooms, the new facility had an emergency room, a surgery room, and a maternity ward. Dr. J. O. Robb and Dr. Archie Pitman also helped Minnie select $9,000 worth of new hospital equipment.

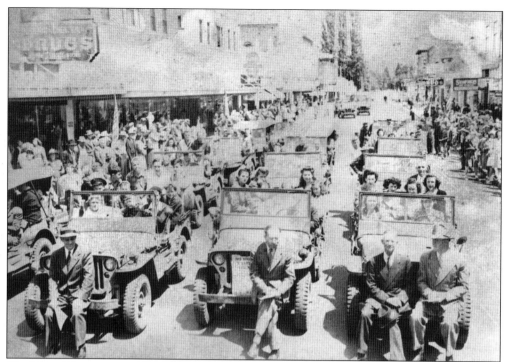

The United States entered World War II in December 1941. The war impacted Hillsboro residents in the same ways it impacted citizens throughout the country: rationing, blackouts, and women in the work force became everyday commonalities. Pictured here is a war rally on Main Street. More than 4,000 Washington County men between the ages of 21 and 36 were called up in the first peacetime selective service draft.

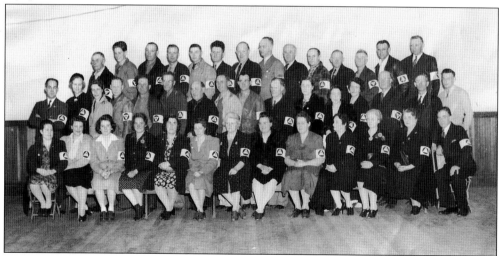

Orenco Civil Defense volunteers, pictured here, were responsible for enforcing blackout laws, manning observation towers, and spotting aircraft. On October 31, 1941, the Civil Defense Division of the War Department conducted a blackout test in which West Coast communities extinguished all nighttime lights during test flights by U.S. Army Air Corps B-17 bombers. Wherever the bomber crews spotted a light on the ground, a flare was dropped to simulate an attack. (Courtesy of Earl Engebretson.)

In the first days after Pearl Harbor in December 1941, Japanese Americans were under suspicion, and on February 19, 1942, U.S. president Franklin Roosevelt gave the War Department authority to evacuate all Japanese Americans from the Pacific states. More than 112,000 people were sent to relocation camps in Arizona, Arkansas, Utah, Idaho, and Wyoming. The Iwasaki family, longtime Hillsboro residents, was relocated to the Ontario and Nyssa areas in eastern Oregon, but their neighbor, Ed Freudenthal, cared for their farm until they returned in 1945.

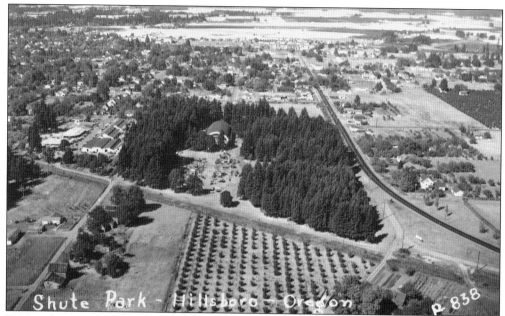

During the war, an Oregon National Guard unit was stationed at the Shute Park Pavilion, seen in this picture at the center of the grove of trees. Hillsboro's Battery E, 218th Field Artillery regiment was deployed from Shute Park to Fort Lewis, Washington, where they spent a year training at the military camp. Tenth Avenue is to the right of the park in this picture, looking north. (Courtesy of Ruth Klein.)

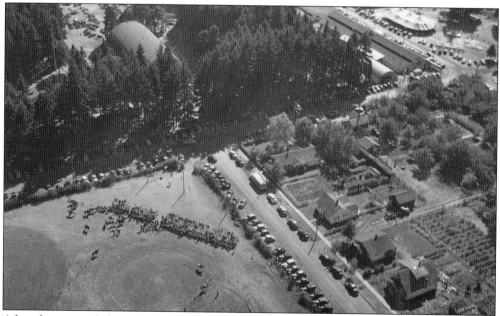

After the war ended on August 14, 1945, spontaneous celebrations occurred throughout the country. U.S. president Harry Truman declared the next two days national holidays, and all stores were closed. Relieved that loved ones would soon be coming home, Hillsboro tried to return to enjoying familiar pastimes. The equestrian event in the foreground of this picture was held on the baseball field opposite Shute Park, now occupied by the Shute Park Aquatic Recreation Center.

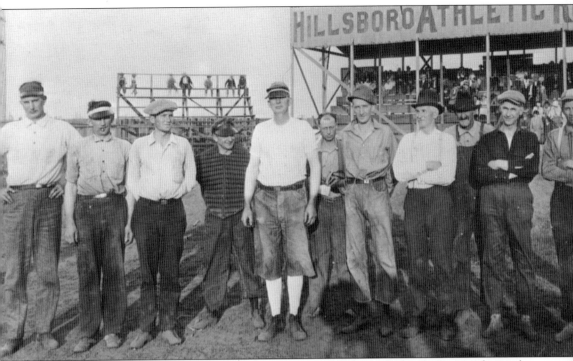

Baseball has always been one of Hillsboro's favorite pastimes, and the city had its first semiprofessional team, the Diamond Ws, early in its history. In addition to constructing movie theaters and the pavilion, and serving as mayor from 1929 to 1935, Orange Phelps loved baseball. He played with the city's next semipro team, the Cardinals, and is shown in this photograph wearing the catcher's chest protector. Verne McKinney, *Argus* publisher, recalled in 1976 that Phelps "had one of the best pegs to second one will ever see." (Courtesy of Mary Stafford.)

In 1949, children at the David Hill Elementary School buried a time capsule containing items from the era on the school grounds. The capsule was scheduled to be recovered in 1999. Pictured here are Lester Mooberry and his wife, who taught in Hillsboro from 1928 to 1955. J. W. Poynter, another well-known Hillsboro educator, is on the left. In addition to being beloved teachers in the community, the Mooberrys were known for their documentation of many facts of the city's history. The Hillsboro School District honored both Lester Mooberry and J. W. Poynter by naming schools after them. (Courtesy of Mary Stafford.)

Six
CHANGES IN OUR SECOND CENTURY

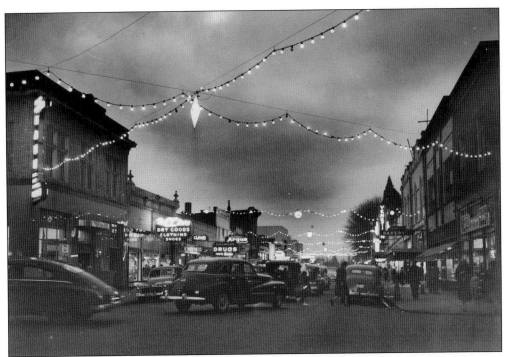

At the beginning of the 1950s, downtown Hillsboro remained relatively unchanged from its appearance at the beginning of the 20th century. This would change by the end of the decade as growth and economics caused redevelopment downtown. This picture, taken at night, shows Main Street looking west from Third Avenue.

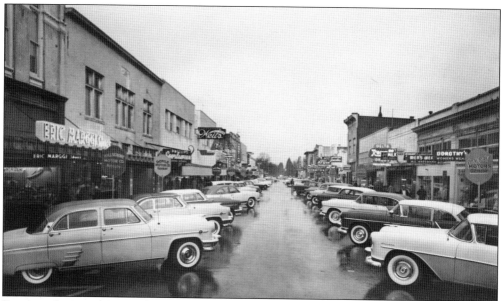

Between the years 1940 and 1950, Hillsboro's population grew 37 percent to 5,142. This growth was primarily due to the need for housing Portland's wartime shipyard workers. In response, the city established a Utilities Commission, which issued bonds to build a new waterline from Haines Falls on the headwaters of the Tualatin River. With the end of rationing, private purchases of cars resumed, as witnessed by the automobile show on Main Street in the 1950s.

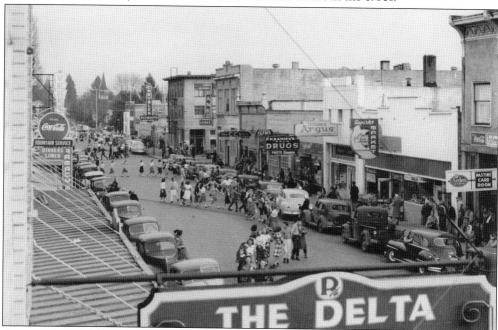

Once a year, on the day of the Fall Football Rally, Hillsboro High School students were released from classes early to continue the tradition of the serpentine walk from the school through downtown Hillsboro. In 1947, the Hilhi Spartans became the first Washington County team to reach the state finals game. Mayor E. A. Griffin issued a proclamation urging businesses to close and citizens to attend the game in Portland.

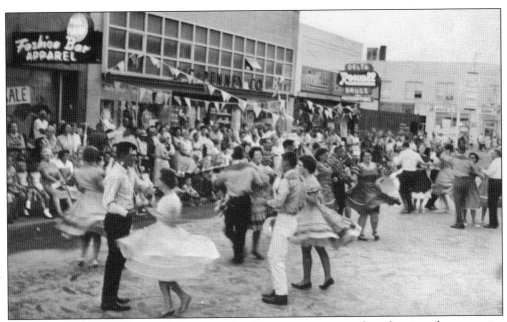

Just as it had been for almost 100 years, the downtown continued as the site of community celebrations like this square dancing exhibition, but the faces of the buildings were beginning to change. Delta Drug had moved from the north side of Main Street to a new location next to the new J. C. Penney building.

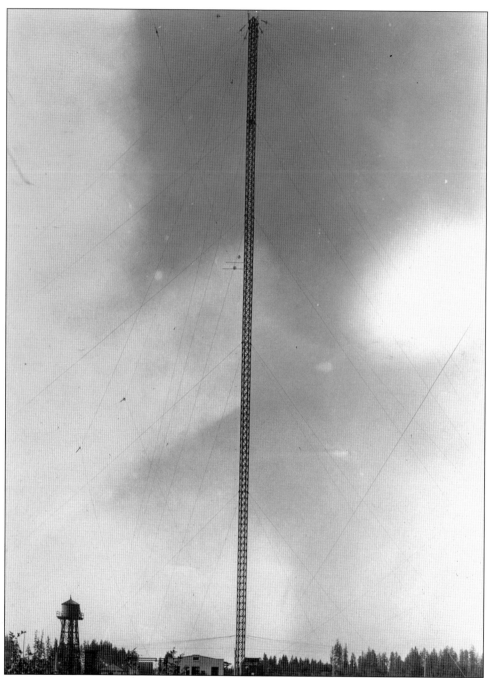

From 1921 through 1952, the second-highest steel tower in the world was located just outside Hillsboro on Rood Bridge Road near the Tualatin River. The radio telegraph transmission tower for the MacKay Radio and Television Company was 626 feet high, second only to the Eiffel Tower. Two hundred acres were needed for the anchors and cables that held the tower in place. The U.S. Coast Guard used the tower and adjacent transmitting station during World War II to send wireless messages. Ed Freudenthal purchased the property, demolished the tower in 1952, and sold the metal for scrap. The tower foundation or the anchors may still remain on the site.

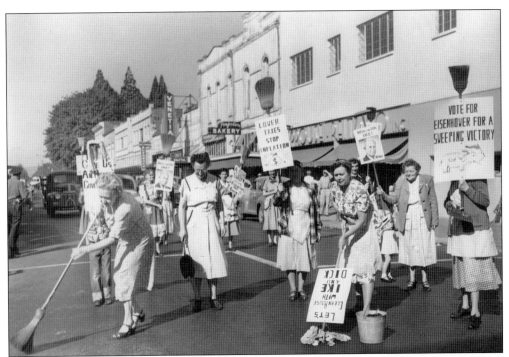

During the 1952 presidential election, these Hillsboro women "swept up" Main Street in support of Dwight "Ike" Eisenhower. Behind them, the original Venetian Theater sign can be seen next to the Perfection Bakery. Weil's Department Store is to the left of the theater.

State senator Paul Patterson (far right), along with his wife, and U.S. Secretary of the Interior Douglas McKay (left) and his wife, Mabel, (second from left) are pictured here in November 1952. Prior to his appointment to the Eisenhower cabinet, McKay had been elected as governor of Oregon in 1948. Patterson was then president of the Oregon Senate and succeeded McKay as governor. He was elected in his own right in 1954 but died in office in 1956.

Before the construction of a city swimming pool, Hillsboro residents enjoyed outdoor swimming at places like Upper Lee Falls on the headwaters of the Tualatin River, pictured here, and in the "Big Bend" of the Tualatin River downstream from the Carnation pumping plant.

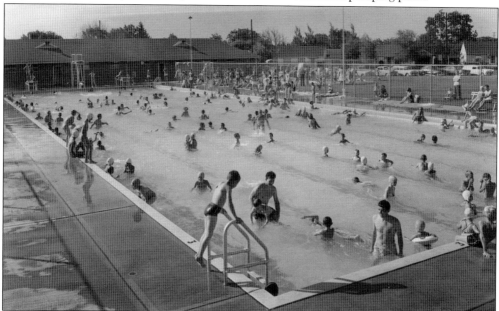

In the 1950s, the city built a 50-by-10-foot outdoor swimming pool on the block across Maple Street from Shute Park. Hillsboro voters approved a $90,000 bond on June 2, 1950, to finance the pool, which opened in 1953. Voters later approved an additional levy of $28,150 to fund a city-directed recreation program. The outdoor pool is still in use today at the Shute Park Aquatic Recreation Center.

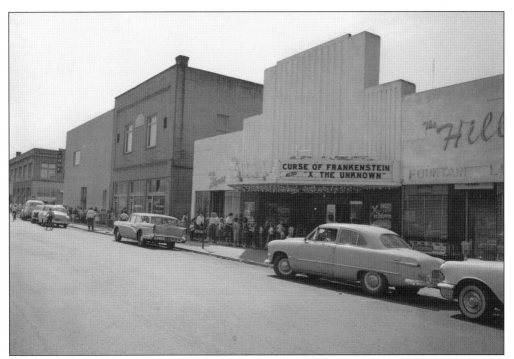

In 1937, Orange Phelps partnered with Harry Hill to build the art deco–style Hill Building on Third Avenue, north of Main Street. Although the Hill Theater did not show first-run movies, as did the Venetian, it always had double features and was well attended. This photograph, taken in the late 1950s, shows a line all the way to Main Street for a horror double feature.

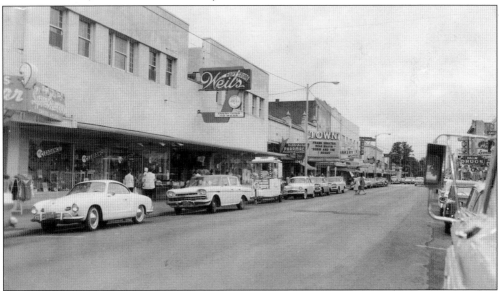

The Venetian Theater burned in 1956 and was rebuilt in 1957. Phelps renamed the refurbished theater the Town, shown here east of Weil's Department Store. Television arrived in Hillsboro in 1952 when the first transmissions were received from Portland. For the first time, residents could enjoy shows in the privacy of their own homes. Televisions were sold at the Selfridge Furniture Store on Baseline Road for $219 to $639. (Courtesy of Mary Stafford.)

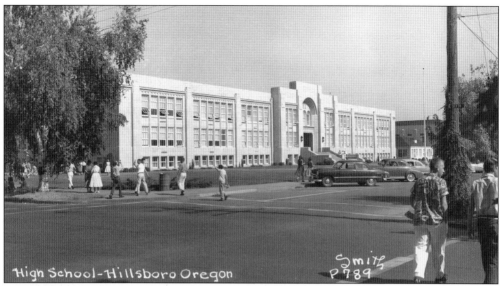

As school populations grew after World War II, the Hillsboro Union High School added wings and new buildings in 1948, again in 1949, and yet again in 1959. Between 1946 and 1970, enrollment grew from 766 to 3,621 students, and in 1970, a new high school was built on Rood Bridge Road. The old Union High School was first renamed Hillsboro Mid High and later the J. B. Thomas Middle School. (Courtesy of Ruth Klein.)

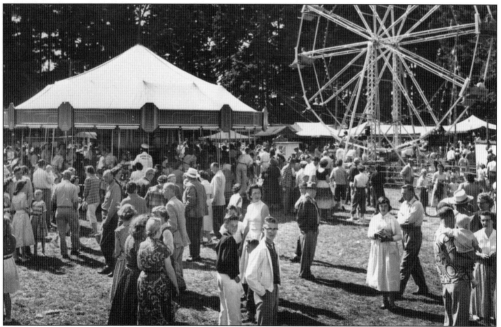

The first county fair at Shute Park in September 1925 featured a rodeo, a stock show, and exhibits of crops, floral arrangements, and art. The fairgrounds consisted of a stock pavilion and a few temporary structures; the Shute Park Pavilion was used for exhibits. Other celebrations such as the 1952 Happy Days were also held there. By the 1950s, the fair outgrew Shute Park, and a new fairground was purchased and improved on 100 acres on Cornell Road, south of the Hillsboro Airport.

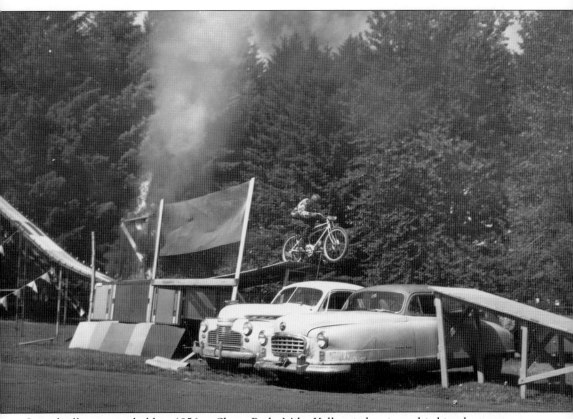

In a thrilling event held in 1956 at Shute Park, Mike Kelly tried to jump his bicycle over two cars in the spirit of Evel Knievel. The attempt was billed as his "Great Last Ride of Death." Unfortunately, Kelly's jump was unsuccessful, and he was treated at the scene for injuries sustained when he fell.

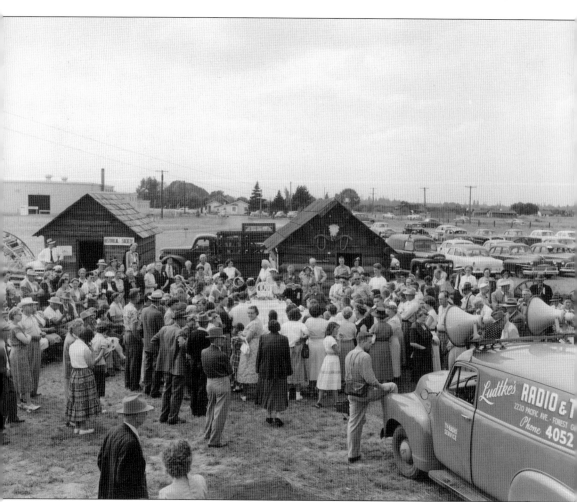

The old county jail (right) and the Washington County Historic Society building (left) can be seen in this photograph taken shortly after the fair moved to its new location on Cornell Road. The Washington County Historical Society was officially formed as a nonprofit organization in 1956 and began sharing stories and displays of Hillsboro's history at the county fair. The old county jail was stored at the fairgrounds until the early 2000s, when it was moved to the Washington County Museum to save it from further deterioration.

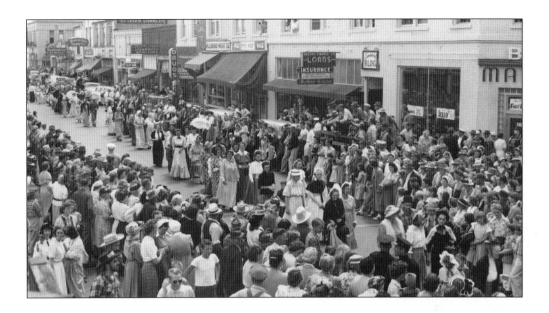

Prior to having an annual Washington County Fair, many local communities held early fall celebrations to celebrate the harvest. But the county fair got an early start in Hillsboro. "Pioneer Ladies on Parade" celebrated the 100th anniversary of the Washington County Fair in 1954. An enormous cake with 100 candles was baked at the Perfection Bakery on Main Street and exhibited in the window there. As befitting an agricultural fair, the cake was transported to the fairgrounds on a flatbed trailer towed by a tractor and was cut on August 29, 1954.

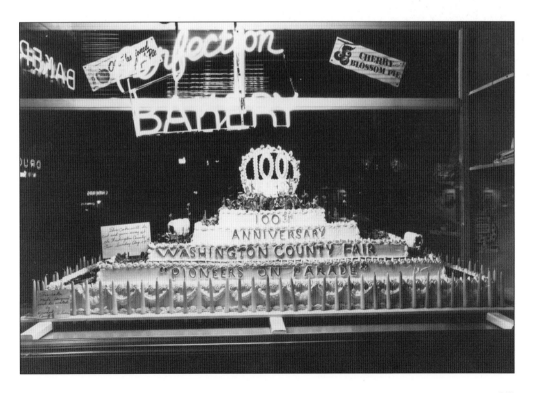

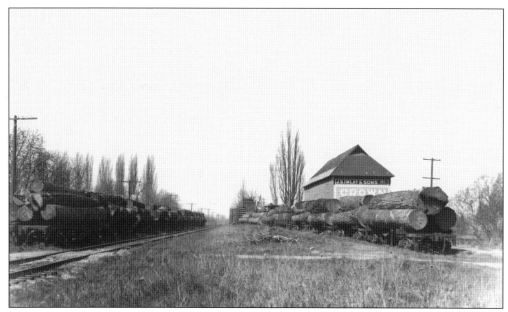

J. B. Imlay moved to Reedville in 1889 and purchased the Reedville Mill, where he operated the grain mill and shipped the grain to feed stores in Hillsboro via the railroad. The Imlay family lived near what is now 209th Avenue. The Imlay Mill was still in operation in 1951, as seen in this picture, taken as log trains passed by.

Orenco Presbyterian Church, one of the few community structures from Orenco that retained its original purpose, was used by the same denomination throughout the 1950s. The building is still used as a church today by the Washington County Unitarian Universalist congregation. The original manse, built as a residence for the Presbyterian pastor, remains just east of the church.

Two long-standing Hillsboro traditions—raising horses and participating in county government—continued together in the 1950s. Volunteer citizens assisted law enforcement in the Sheriff's Mounted Posse, shown in this picture on the courthouse grounds. Then, and continuing today, the sheriff's posse was a regular entry in the Fourth of July parade. (Courtesy of Mary Stafford.)

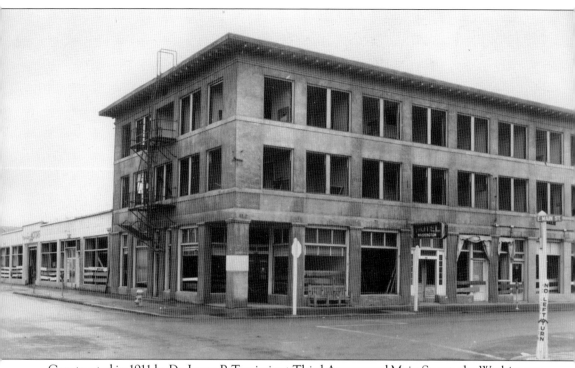

Constructed in 1911 by Dr. James P. Tamiesie at Third Avenue and Main Street, the Washington Hotel had 56 guest rooms, six baths, and four lavatories. Its fine amenities included patios, a formal garden at the rear, and an outstanding restaurant, which enticed even Portlanders to come out to Hillsboro. The hotel was sold by the Tamiesie estate to Washington Federal Savings and Loan and was demolished in 1956 to construct a new bank building.

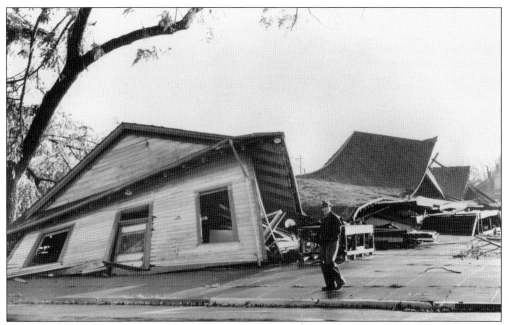

The 1962 Columbus Day Storm, also known as the "Big Blow," was an extra-tropical cyclone that wreaked havoc throughout the Pacific Northwest. In Hillsboro, buildings were flattened, roofs blown away, and huge trees toppled. The Congregational Church at Fourth Avenue and Main Street lost its steeple, and the derelict Oregon Pacific Railroad station collapsed (pictured above). Power was knocked out for days afterwards, and Washington County suffered an estimated $5.5 million in damages.

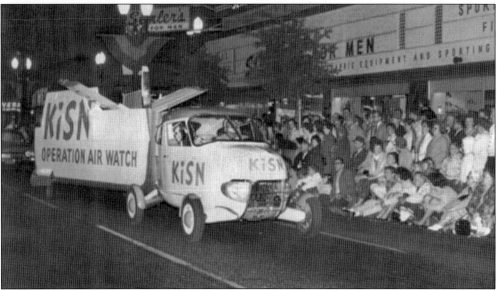

Hillsboro was home to a unique survivor of the Big Blow: the KISN Airwatch aero-car. The Portland radio station sponsored the traffic-watch aircraft, pictured here during a parade in Portland. The plane was based at Wik's Air Service at the Hillsboro Airport, and Ruth Wikander was one of the pilots. The aero-car took off from Hillsboro Airport in the afternoon of the 1962 Columbus Day windstorm and amazingly survived the storm without damage.

Following their forced relocation during World War II, the Iwasaki family returned to their farm south of Hillsboro and built greenhouses for their nurseries. The nursery business thrived in Washington County, continuing the tradition established by the Oregon Nursery Company. As noted in the *Argus* in 1976, this valley was one of the finest areas in America for growing ornamental nursery crops. The business grew from $50,000 in 1927 to $8 million by 1974.

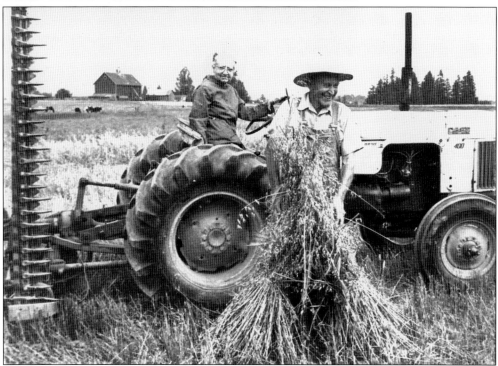

Swiss and German families, like that of Esther and Walter Stucki (pictured here), settled here in the late 1800s when agriculture was still the major industry. Hillsboro Farm Equipment, located on Southwest Baseline Road, was one of the oldest International Harvester dealerships in Oregon west of the Cascade Mountains. The Schneiders operated this essential business and witnessed the evolution of farm machinery from early gasoline tractors to huge equipment capable of pulling almost a dozen 16-inch disks. (Courtesy of Harold Berger.)

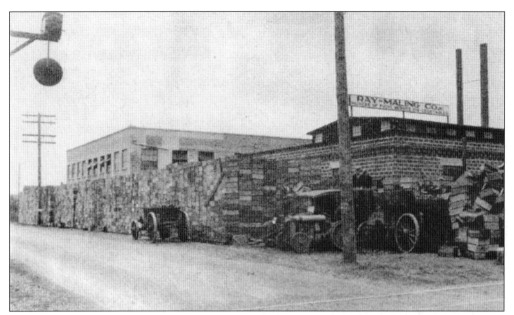

By 1960, Birdseye Frozen Foods was Hillsboro's largest employer. Formerly the Ray-Mailing Cannery, Birdseye packed the first commercially frozen foods here in 1929. The Hillsboro plant employed 100 workers year-round and up to 1,000 during the peak growing season. Birdseye regional offices were located in downtown Hillsboro, where 65 employees were responsible for coordinating five Pacific Coast plants. (Courtesy of Hillsboro *Argus*.)

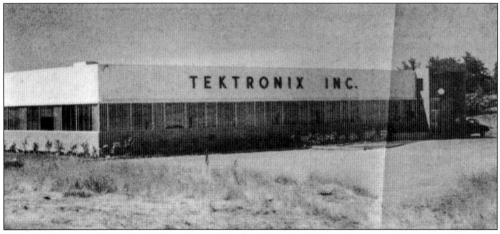

Tektronix was established in 1951 at Barnes Road and Sunset Highway to manufacture oscilloscopes. By 1959, it had nearly 10,000 employees at several locations throughout the Willamette Valley. Tektronix, employing about 1,600 Hillsboro residents by the end of the 1950s, led the way for Intel and other electronics and high tech firms to put down roots in Hillsboro. By the late 1980s, the Sunset Highway Corridor north and east of Hillsboro became known as the "Silicon Forest."

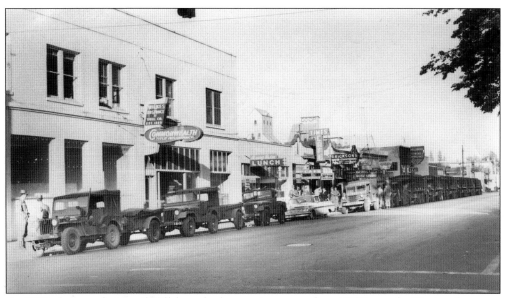

By 1960, the population of Hillsboro had grown to more than 7,000 people. National events, such as the war in Vietnam, began to interrupt local life again. Shown in this picture are army vehicles parked along a downtown street in preparation for deployment to Vietnam.

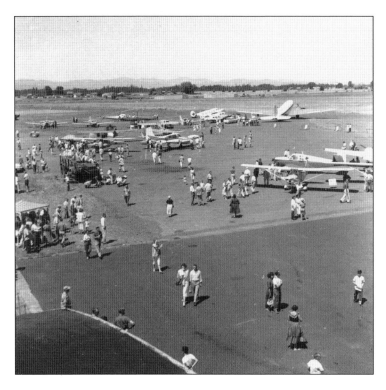

The 1961 Jaycees Air Show, a precursor to today's Oregon International Air Show, drew a large crowd for its day. In 1966, the city transferred ownership of the airport to the Port of Portland, and the existing runways were extended and refurbished. The Port of Portland also built new hangars, a new air-control tower, and a new 6,300-foot runway. Hillsboro Airport is now the busiest general aviation airport in Oregon. (Courtesy of Dana McCullough.)

The city and the chamber of commerce created the Hillsboro Industrial Development Corporation in 1957 and purchased 41 acres on the west side of town for resale as industrial sites. Today Hillsboro continues as a regional leader in industrial development. This picture, taken in the 1970s, shows the former city hall at Washington Street and Second Avenue. The building, constructed in the 1890s and later remodeled, originally contained both a fire station and a fraternal lodge.

Wess Hebron's barbershop on Baseline Street, a local landmark until 1997, continued the tradition of Hillsboro businesses' personal services. As reported in the *Argus* in 1913, Clyde Bowler travelled from Yamhill County to get a haircut at a real barbershop since his wife, Elvira, had cut his hair a few days earlier. The barber reported that "when he uncovered his head he exhibited just about the most cantankerous, ornery and ridiculous haircut ever seen on a man's bean."

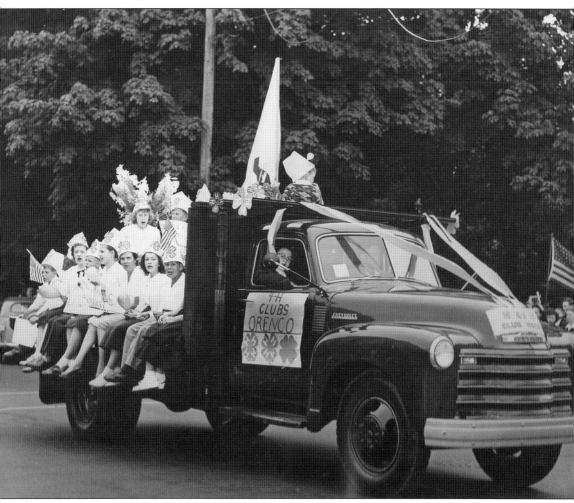

The bicentennial and Hillsboro's 100th birthday were celebrated throughout the community. A special commemorative issue of the *Hillsboro Argus* was published on October 19, 1976, in honor of Hillsboro's receipt of its city charter exactly 100 years before. By 1976, the city had transformed itself from its frontier "Sin City" origins to a balanced family community on the brink of becoming a new center for the high tech industry. (Courtesy of Harold Berger.)

BIBLIOGRAPHY

Bourke, Paul and Donald DeBats. *Washington County: Politics and Community in Antebellum America*. Baltimore, MD: Johns Hopkins University Press, 1995.

Buan, Carolyn M. *This Far-Off Sunset Land: A Pictorial History of Washington County, Oregon*. Virginia Beach, VA: Donning Company Publishers, 1999.

Clifford, Terry Hastings and Joseph Montalbano. *Hillsboro: My Home Town*. Hillsboro, OR: Hillsboro Elementary School District No. 7, 1980.

Hillsboro Argus. Special Centennial Edition. Hillsboro, OR: *Hillsboro Argus*, October 19, 1976.

Lee, Marshall M. *Tuality Community Hospital and the Triumph of General Medicine*. Hillsboro, OR: Tuality Community Hospital, 1992.

Matthews, Richard P. *History of Hillsboro, Excerpt*. Hillsboro, OR: unpublished, 1985.

———. *Limited Horizon's on the Oregon Frontier: East Tualatin Plains and the Town of Hillsboro, Washington County, 1840–1890*. Portland, OR: Portland State University, 1988.

The Provisional League of Women Voters. *This is Hillsboro*. Hillsboro, OR: The Provisional League of Women Voters.

Stafford, Mary. *Hillsboro: Important Facts of Our Home Town, Teachers Guide*. Self-published, 1976.

Welcome to Hillsboro: The Hub of Washington County, 1876. Hillsboro, OR: City of Hillsboro, 1976.

www.arcadiapublishing.com

Discover books about the town where you grew up, the cities where your friends and families live, the town where your parents met, or even that retirement spot you've been dreaming about. Our Web site provides history lovers with exclusive deals, advanced notification about new titles, e-mail alerts of author events, and much more.

Arcadia Publishing, the leading local history publisher in the United States, is committed to making history accessible and meaningful through publishing books that celebrate and preserve the heritage of America's people and places. Consistent with our mission to preserve history on a local level, this book was printed in South Carolina on American-made paper and manufactured entirely in the United States.

This book carries the accredited Forest Stewardship Council (FSC) label and is printed on 100 percent FSC-certified paper. Products carrying the FSC label are independently certified to assure consumers that they come from forests that are managed to meet the social, economic, and ecological needs of present and future generations.

FSC
Mixed Sources
Product group from well-managed forests and other controlled sources

Cert no. SW-COC-001530
www.fsc.org
© 1996 Forest Stewardship Council

Find Your Place in History.